faces
IN PLACES

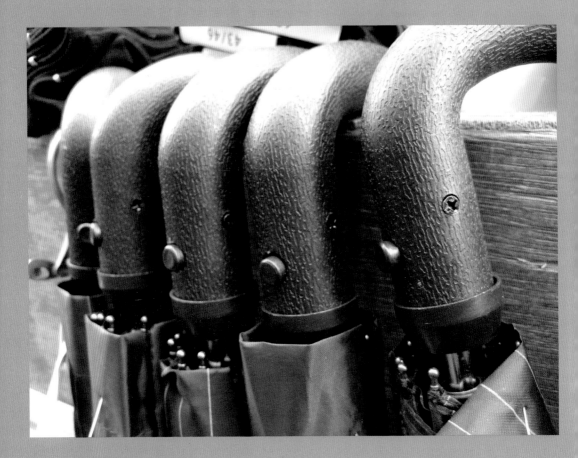

faces
IN PLACES

Compiled by Jody Smith

First published 2010 by
Ammonite Press
an imprint of AE Publications Ltd,
166 High Street, Lewes, East Sussex, BN7 1XU

Reprinted 2011

ISBN 978-1-906672-90-4

Compiler: Jody Smith
Editor: Richard Wiles
Designer: Adam Carter

Colour reproduction by GMC Reprographics

Printed and bound in China by 1010 Printing International Ltd

CONTENTS

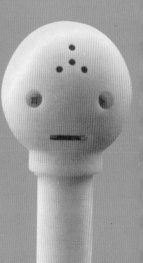

INTRODUCTION

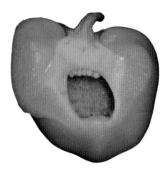

Faces are brilliant! Without them we couldn't smile, laugh, frown, scowl or scream. But they're not always attached to a head. In fact, this book will make you believe they're more commonly attached to bath tubs, shoes and biscuits, among other things.

That's because faces are everywhere. And if you don't believe me, look around. There's probably a face staring at you right now...

Faces in Places started life on my camera: a few random objects I'd idly snapped when out and about that resembled faces. I posted them on the photo sharing website Flickr and suddenly realised I wasn't alone in spotting faces on inanimate objects. I invited other face-spotters to contribute their photos to an online group until it grew to be so big that I decided there had to be a way to showcase the very best finds.

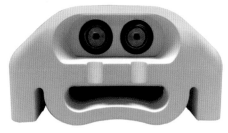

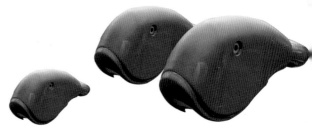

So I launched the **Faces in Places** blog in 2007 and suddenly a movement was born. Photos flooded in faster than I could blog them and now more than 4,000 people have contributed around 20,000 photos to the website.

This book features the finest, funniest and most intriguing faces, and I'm hoping it will make you grin from ear to ear – not only because it's 100% awesome, but also because 10% of profits go to charity. Hope For Children helps disabled, orphaned, poor and exploited children by assisting their rights to basic necessities, such as education and health care. So thanks for putting a smile on a child's face by buying it!

For more faces in places (and to submit your own) visit:
www.facesinplaces.biz

Enjoy the book and happy face hunting!

Jody Smith

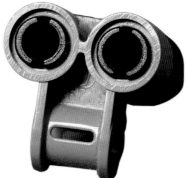

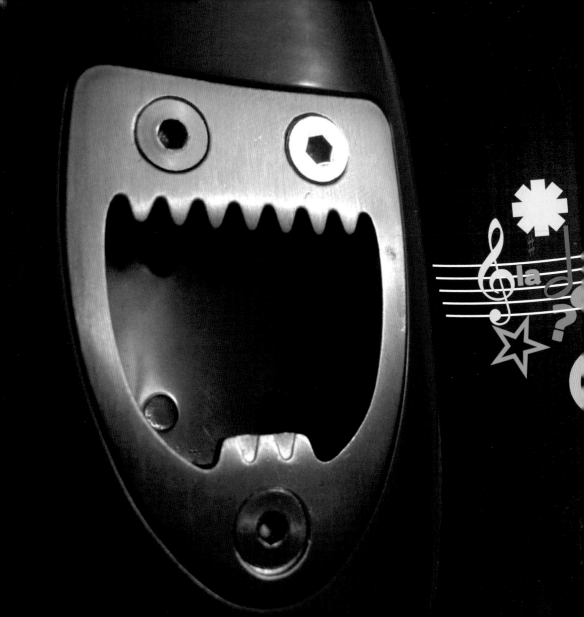

Chapter 1

Express Yourself

This rogue's gallery of emotionally charged faces displays a range of expressions from curiosity, amusement and frivolity, to surprise, boredom, unabashed love and happiness.

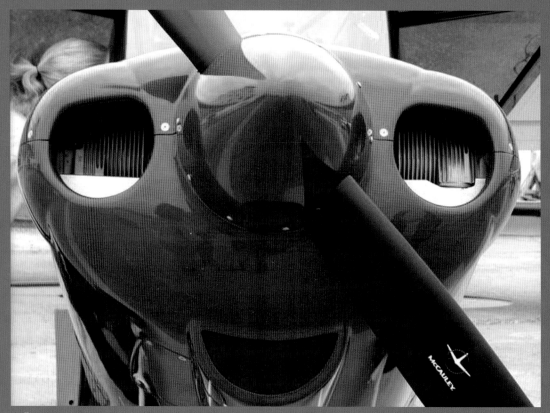

Plane happy

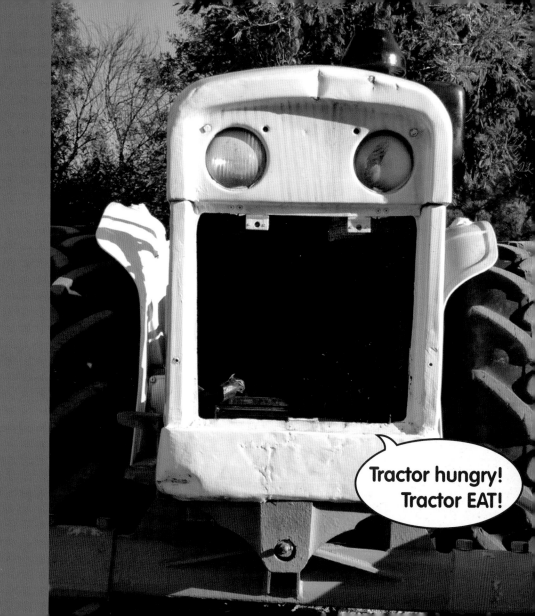

Puckering petals

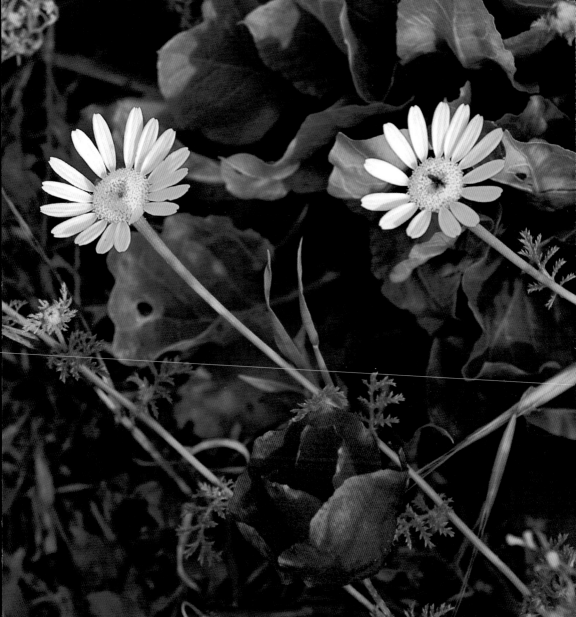

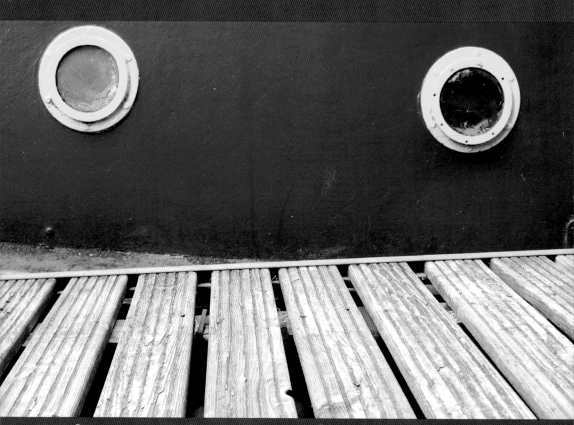

Check out my decking dentistry!

I'm a shaaaark!

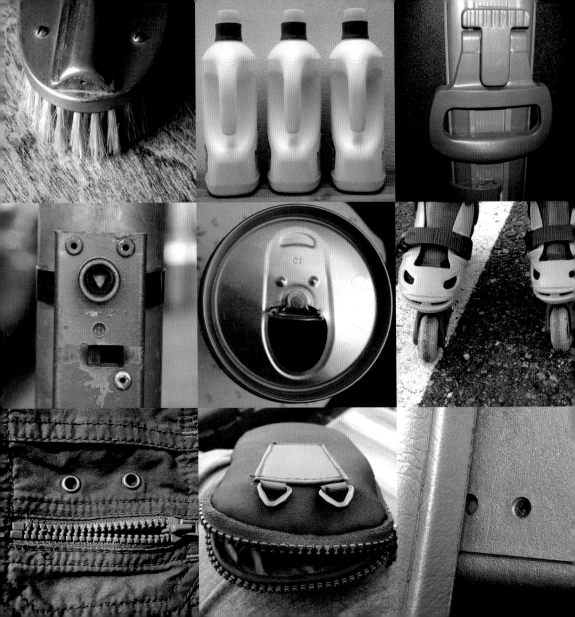

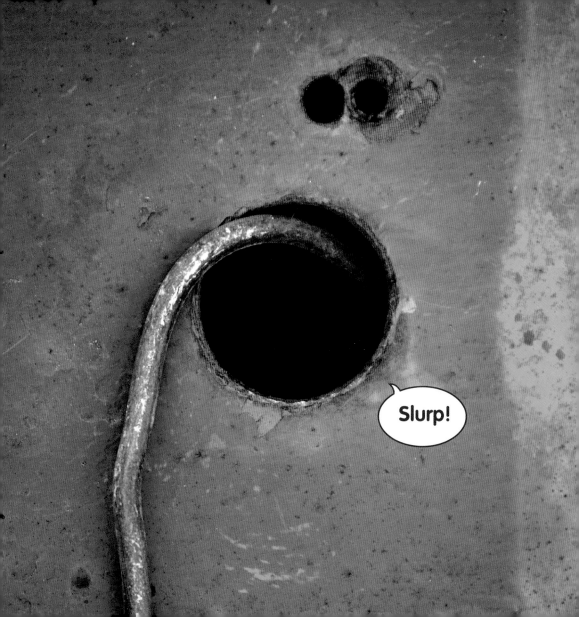

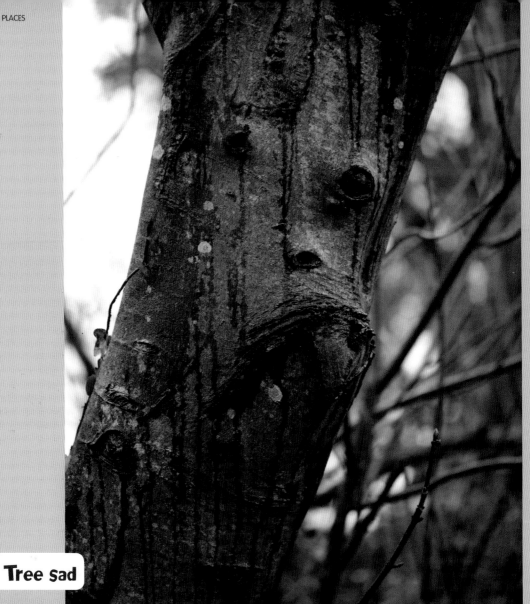

Tree sad

Tiki time

Cable guy

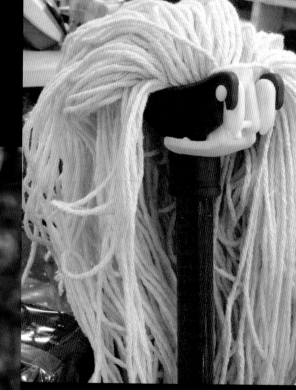

Mop 'n' roll stars

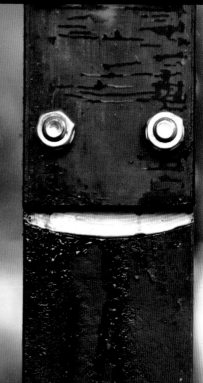

Post daze

Road rage

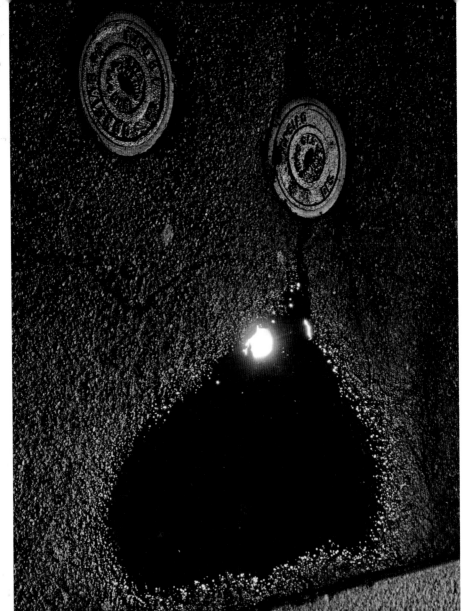

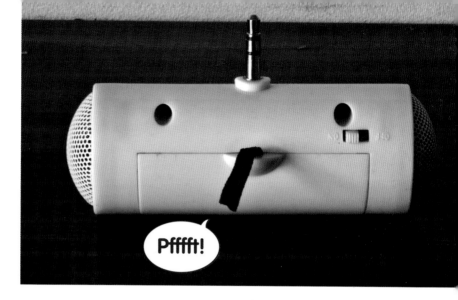

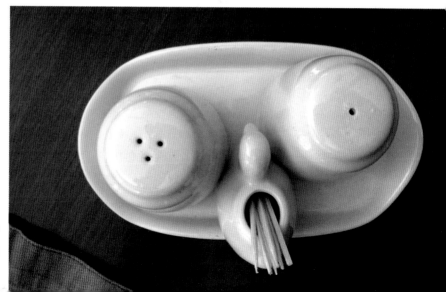

Picky
tastes

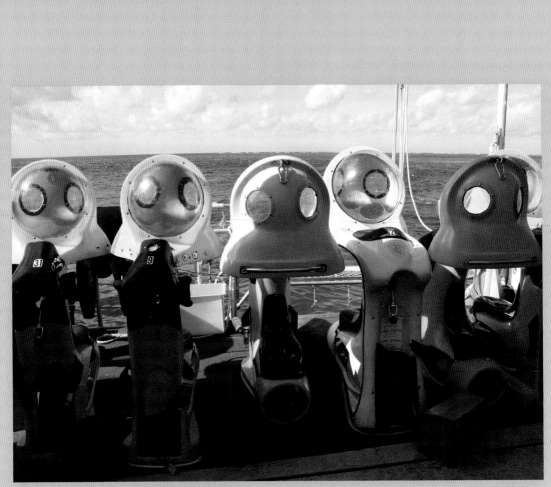

Ahoy there, land lubber!

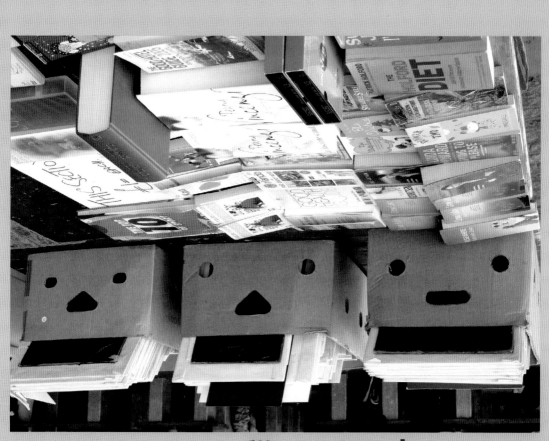

We come from a land down under

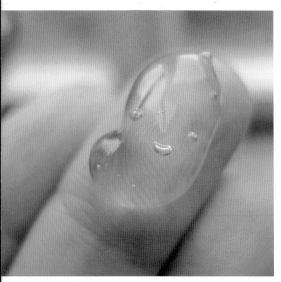

Mr Blobby

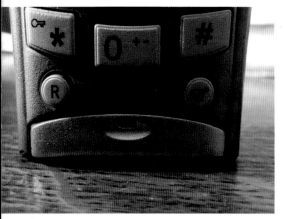

Control freak

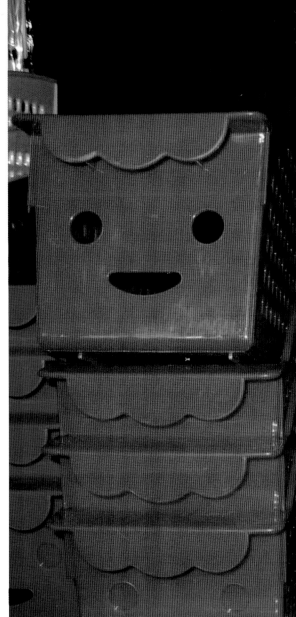

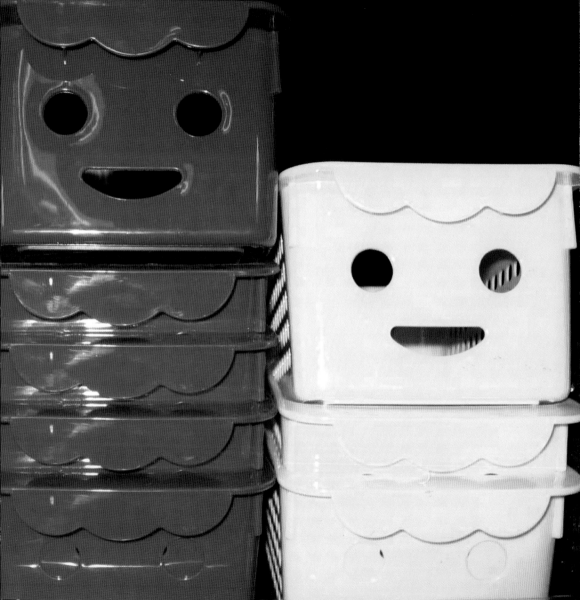

Red-eye reduction

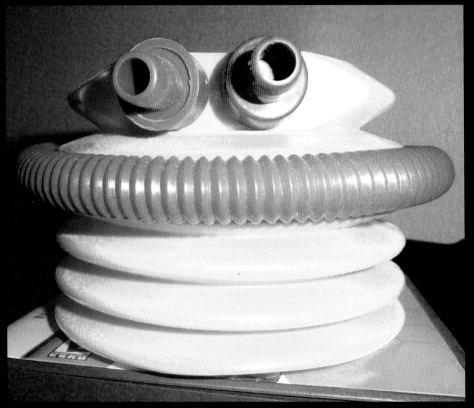

Head in the clouds »

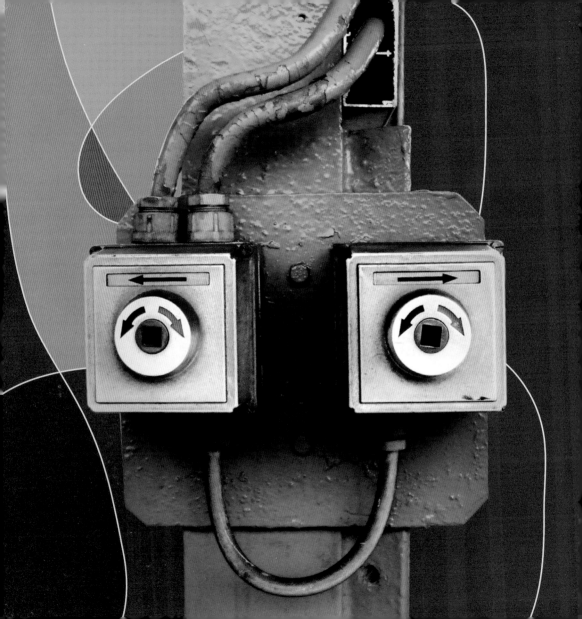

Chapter 2

Happy And Sad

Giggling, smirking or exuberantly happy faces are to be found everywhere – but amid the guffaws and belly laughs, there are also some characters who could really do with a hug.

Bag of laughs

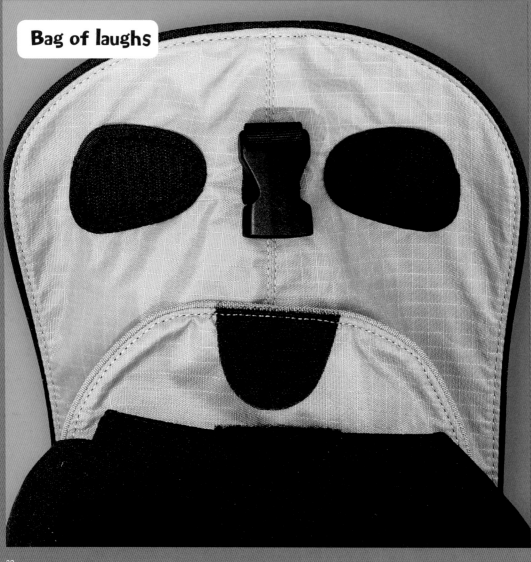

Iron man

High flyer

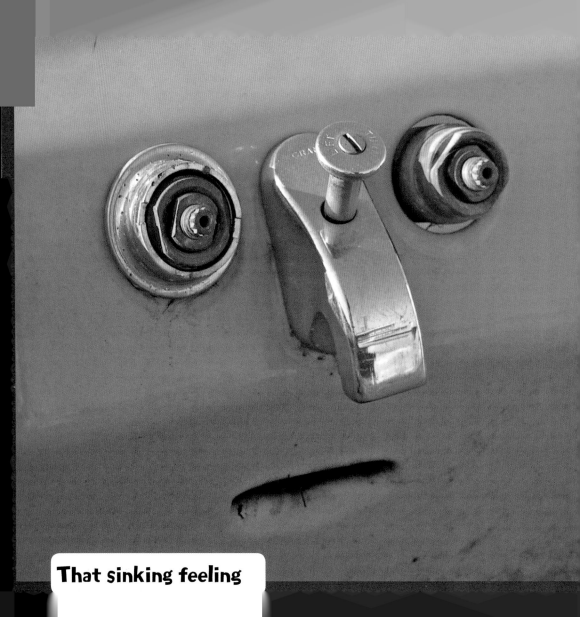

That sinking feeling

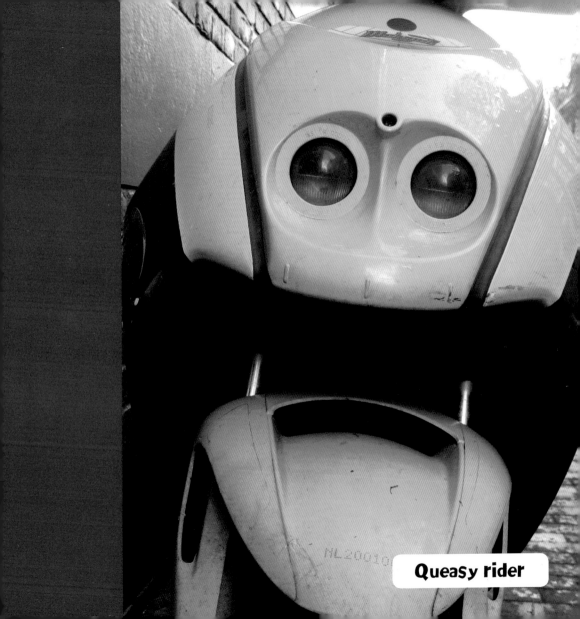

Queasy rider

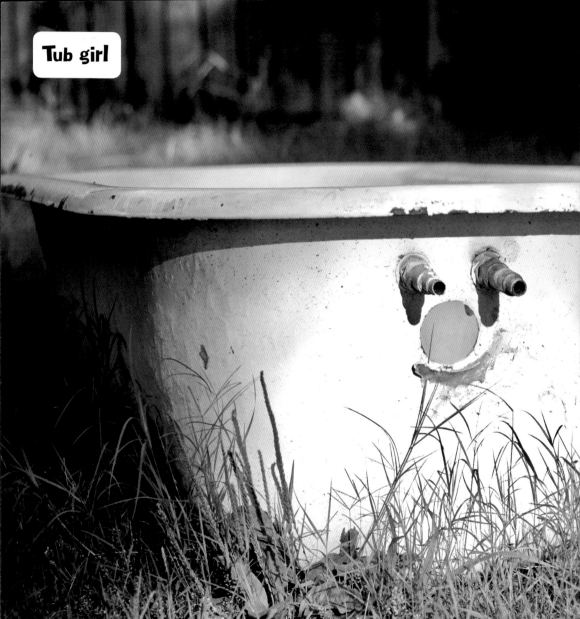

Tub girl

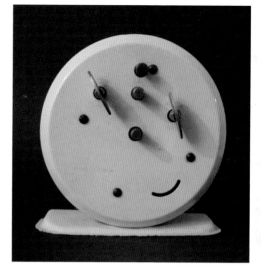

Good times

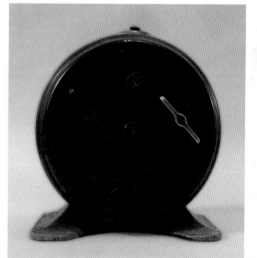

Bad times

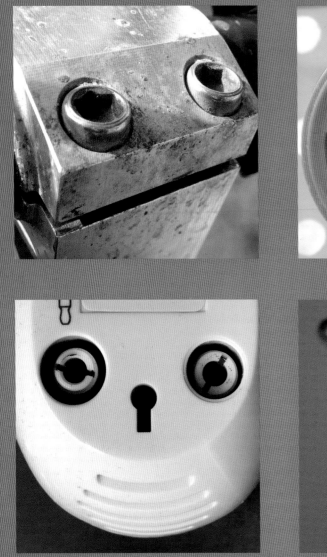
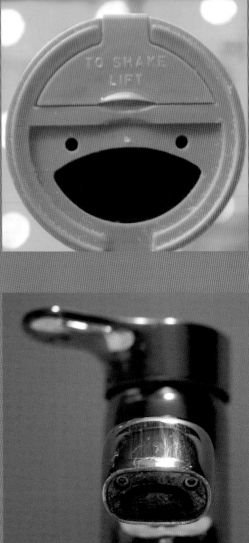

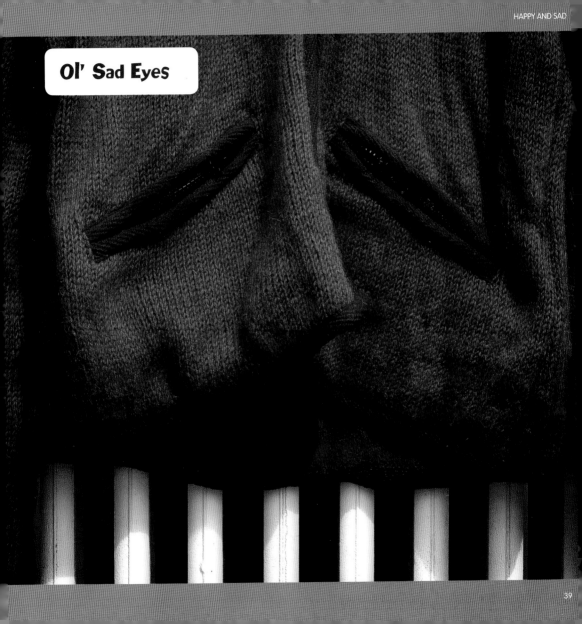

Ol' Sad Eyes

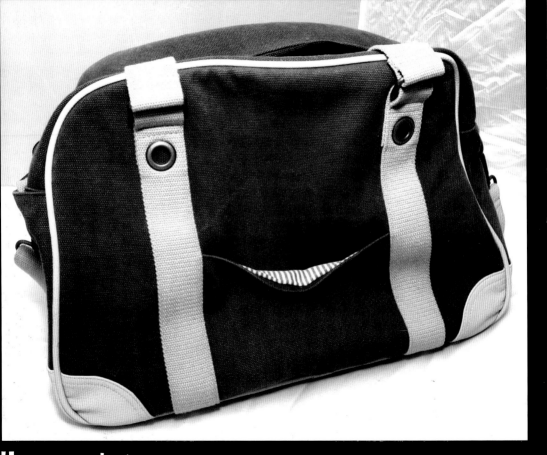

Happy man bag

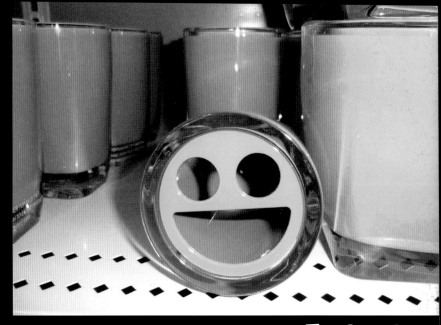

Toothy grin

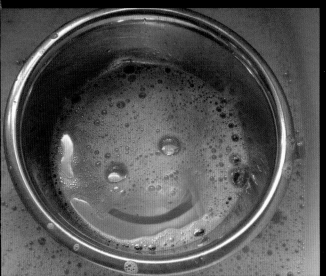

Smiley bubbles

Sooo board

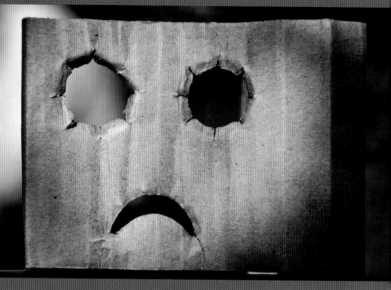

Feeling grate

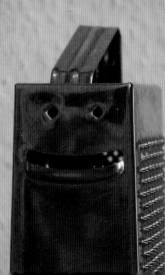

Wired for sound

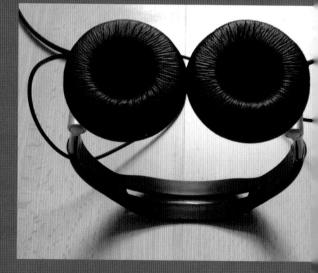

Don't worry, tree happy

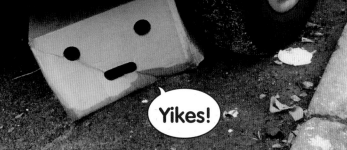

Yikes!

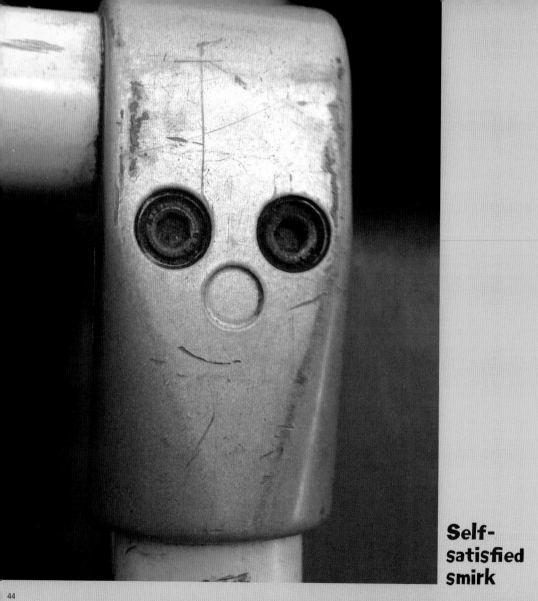

Self-satisfied smirk

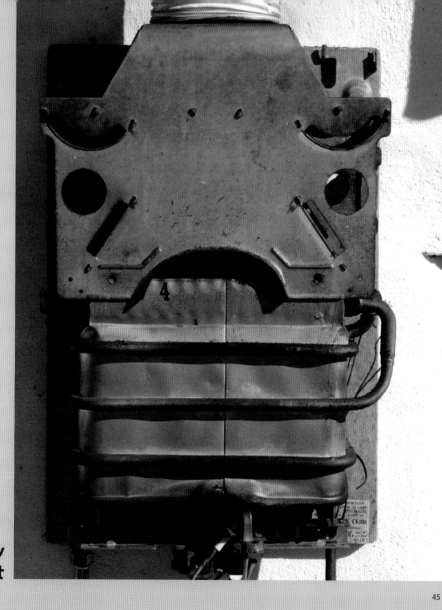

**Worry
bot**

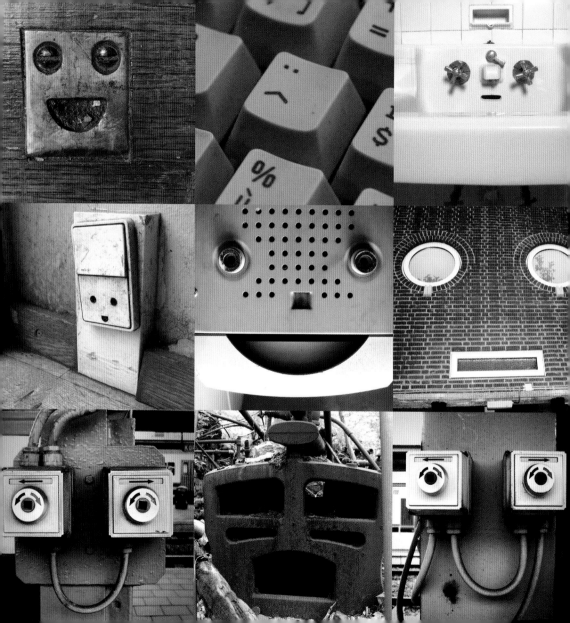

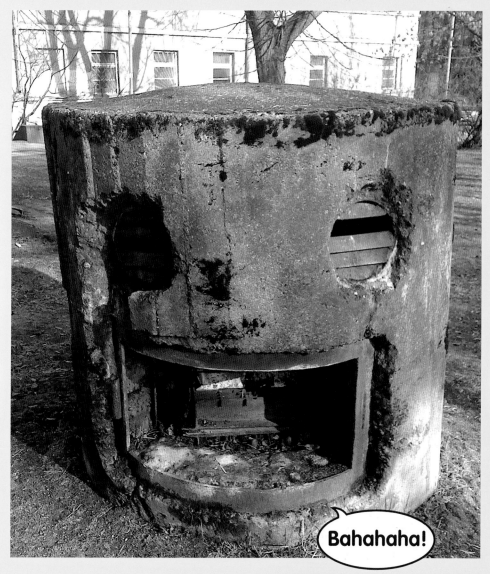

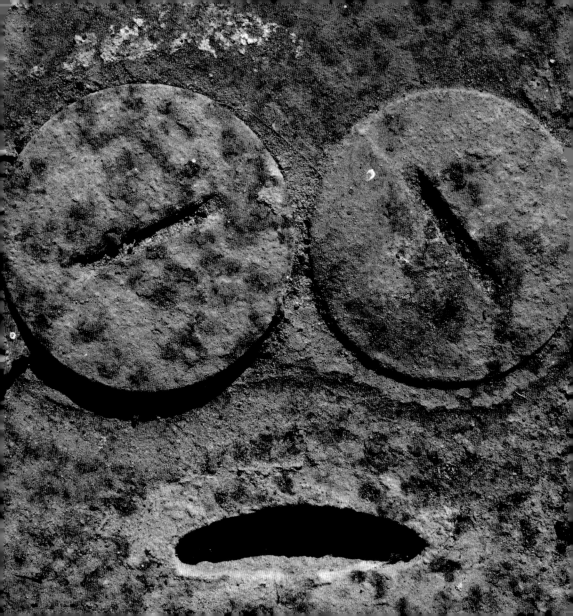

« **The great depression**

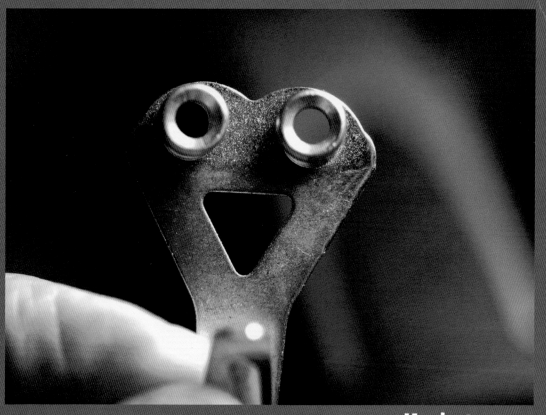

Hooked on you

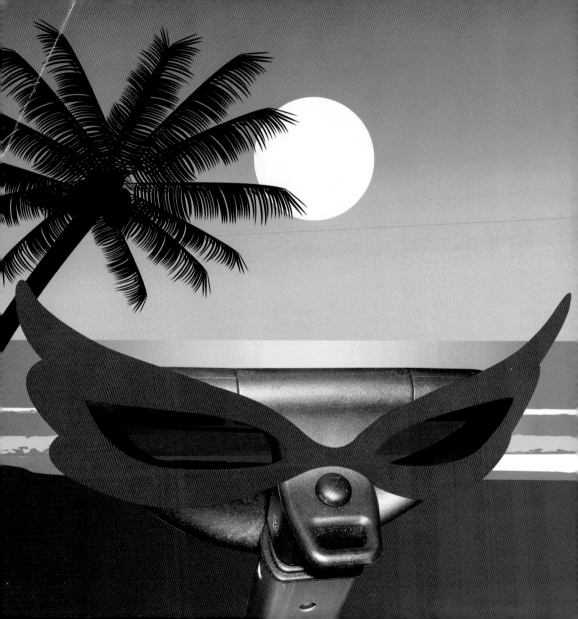

Chapter 3

Name That Face!

Can you name the everyday objects that the following faces belong to? Test your friends; and if you're stuck, turn the page upside down for the answer. No cheating! You're being watched.

① ☆ Sit on my face

② Get a grip

1 Chair cushion 2 Running machine handle

˄ Furry friend ③

A real sucker ④

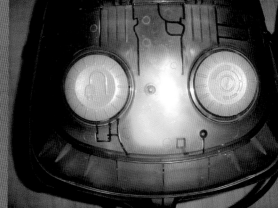

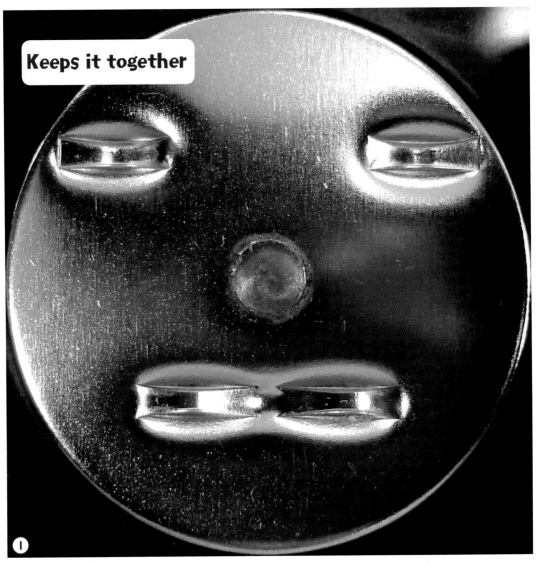

Keeps it together

1 Stapler

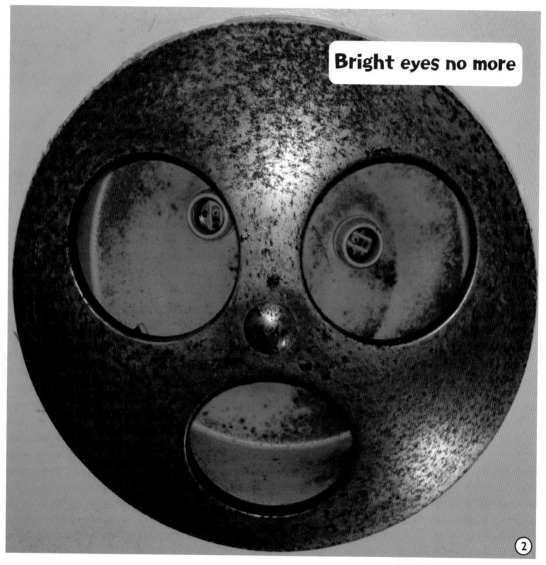

Bright eyes no more

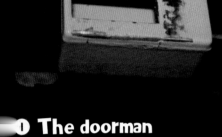

❶ The doorman

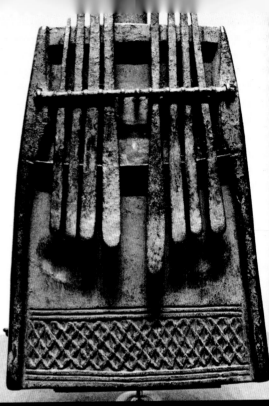

❷ Plinky plonky

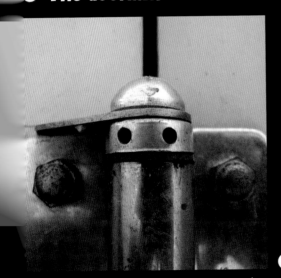

❸ Open-and-shut case

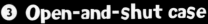

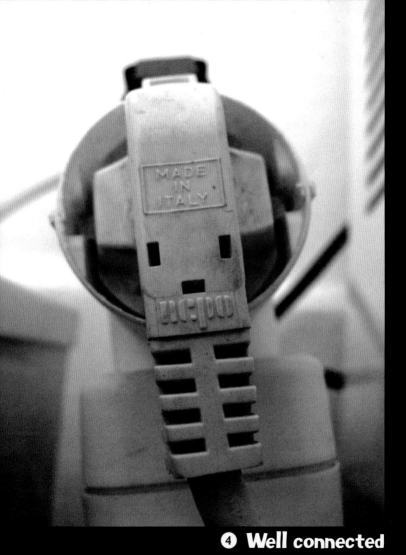

❹ Well connected

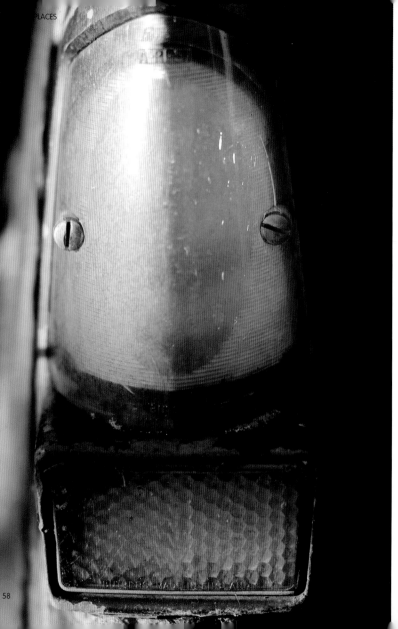

① **Which way now?**

② » **What's the link?**

1 Car indicator 2 Bike chain

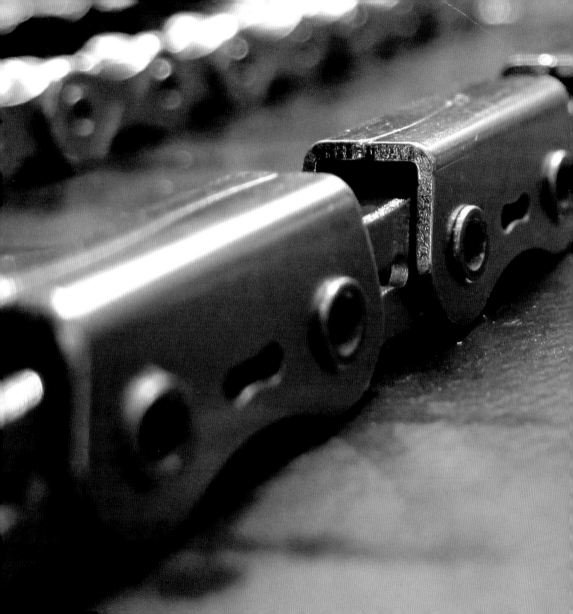

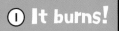

1 **It burns!**

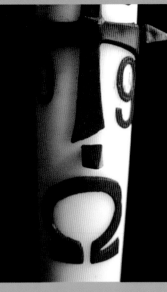

2 » **Don't get caught**

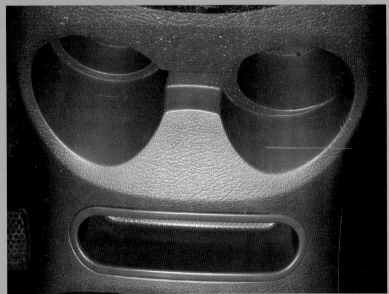

3 **I need a drink**

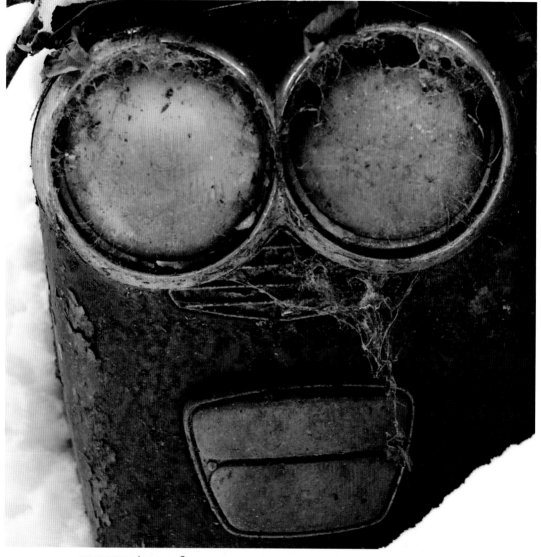

① **Fancy a tune?**

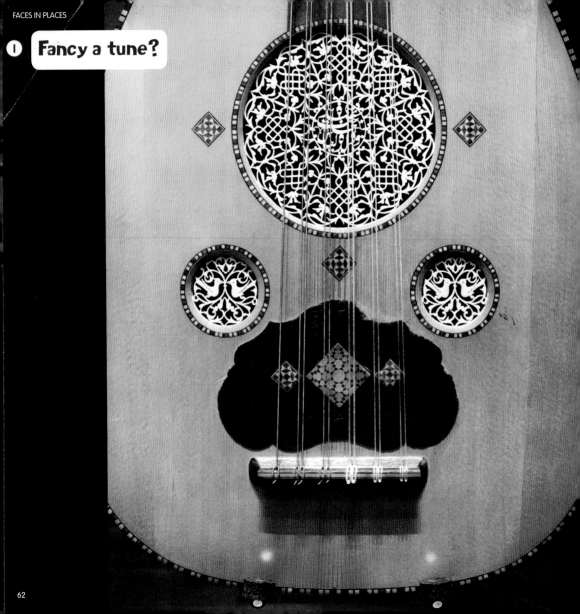

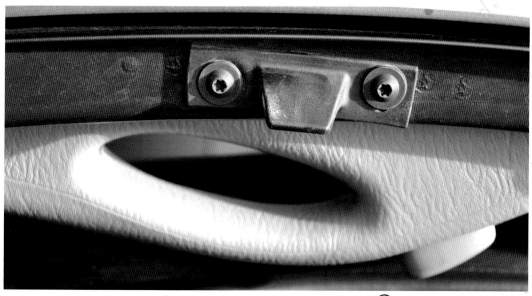

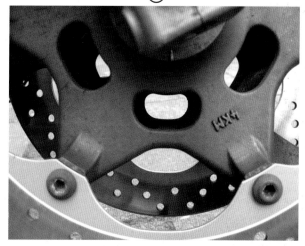

② ⌣ **Wee don't know him**

③ **Motor mouths**
④

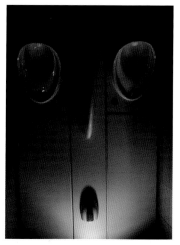

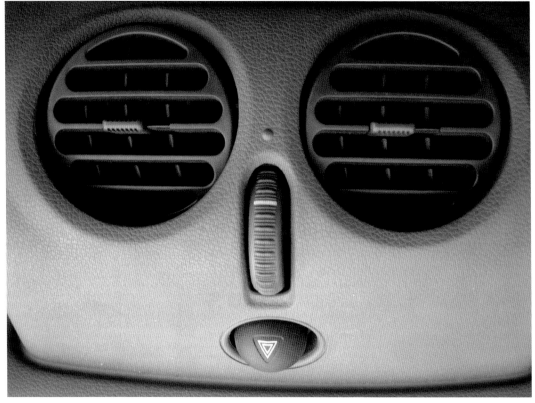

① **Airy eyeballs**

1 Car ventilators 2 Saucepan handle

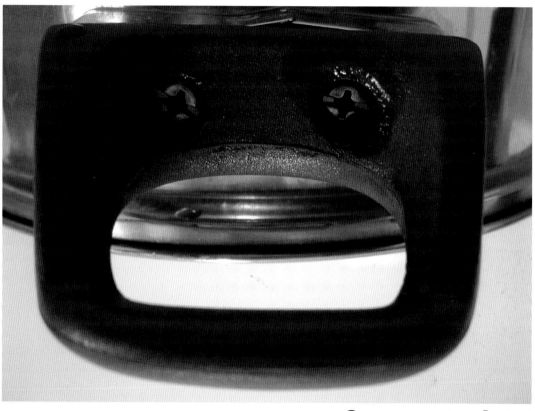

② **Can you handle it?**

1 **Junk food diet**

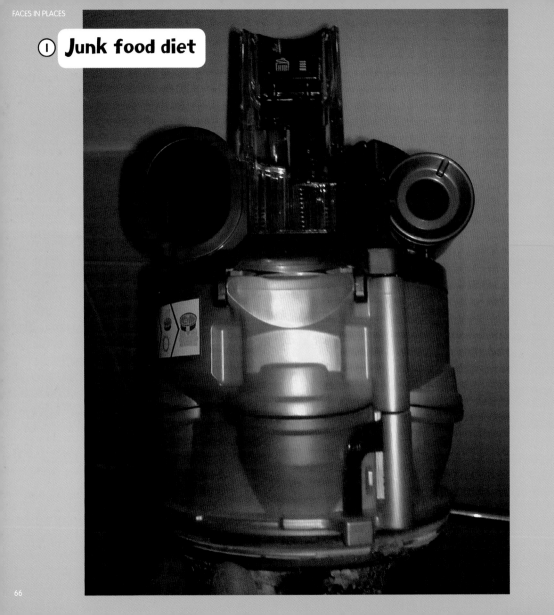

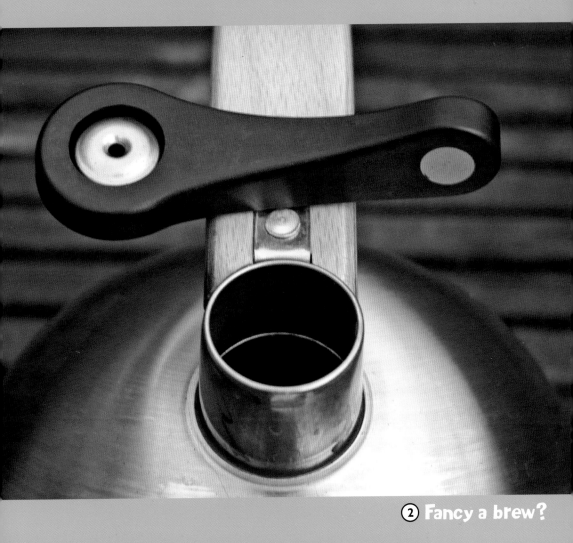

② **Fancy a brew?**

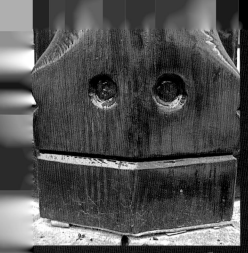

❶ He's been framed!

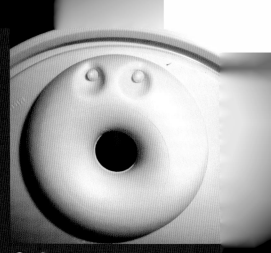

❷ Gone potty

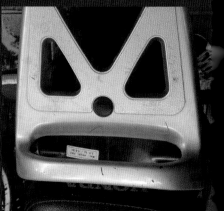

❸ No staple diet

❹ Quick rack

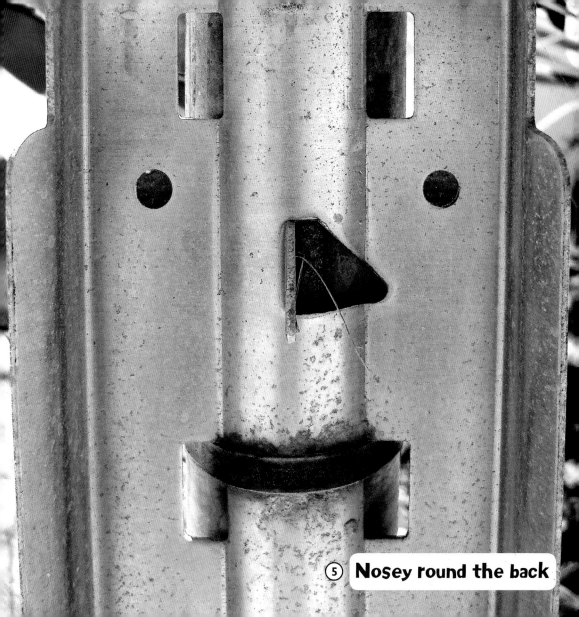

⑤ **Nosey round the back**

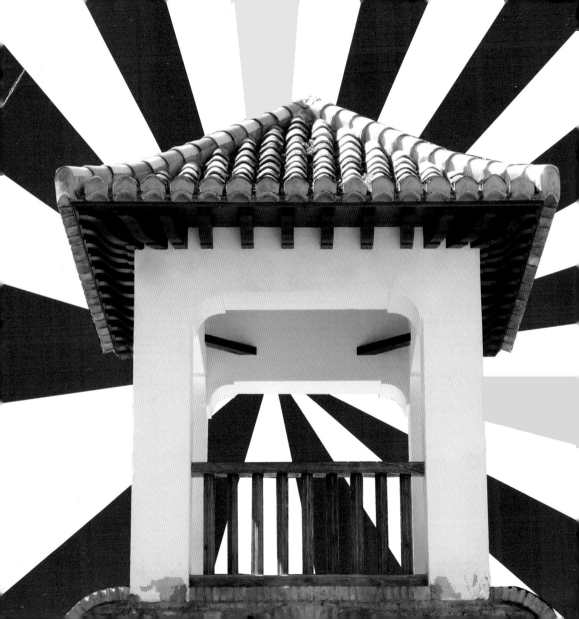

Chapter 4

Street Mates

Never feel alone when out for a walk – there are friendly faces watching you everywhere, on buildings, road signs, fire hydrants, advertising hoardings and other street furniture.

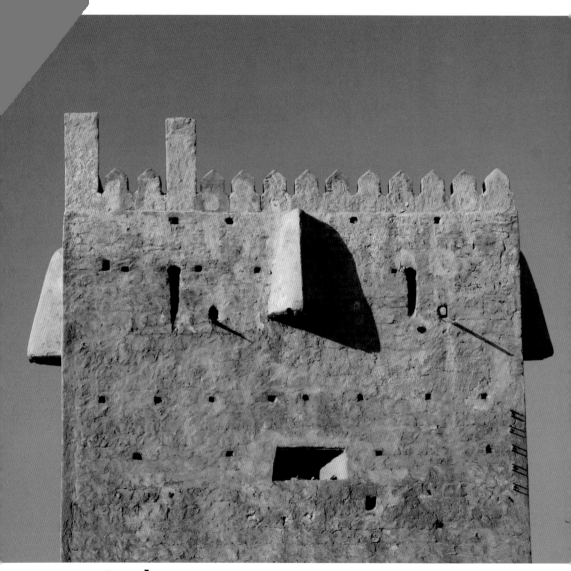

Battlement buddy

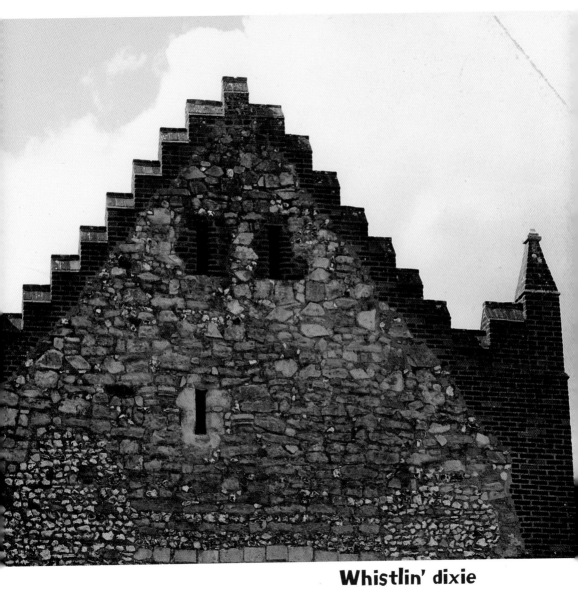

Whistlin' dixie

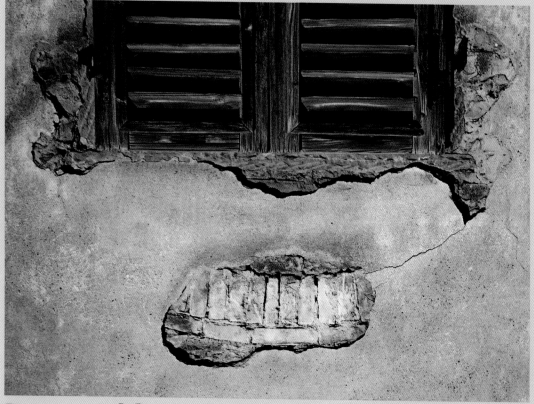

Brace yourself!

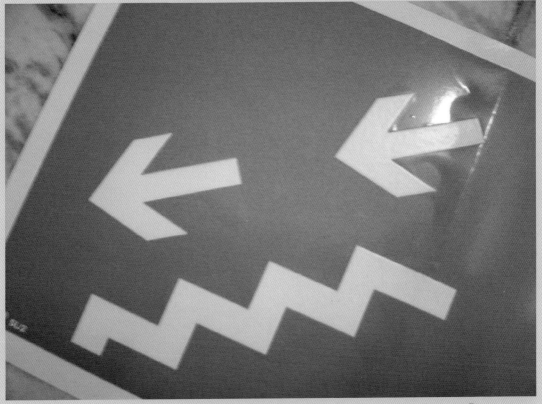

A troubled sign

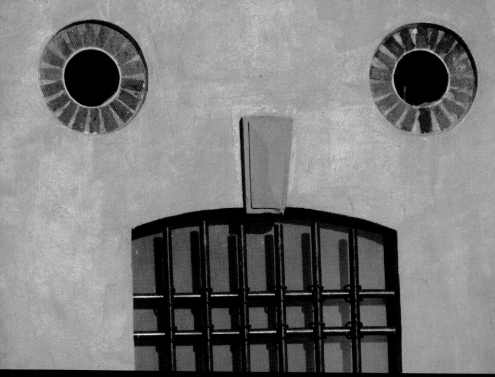

Whadda I do?!

Mellow yellow

« **Mr Nosey on the look out**

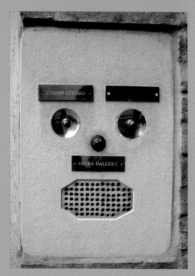

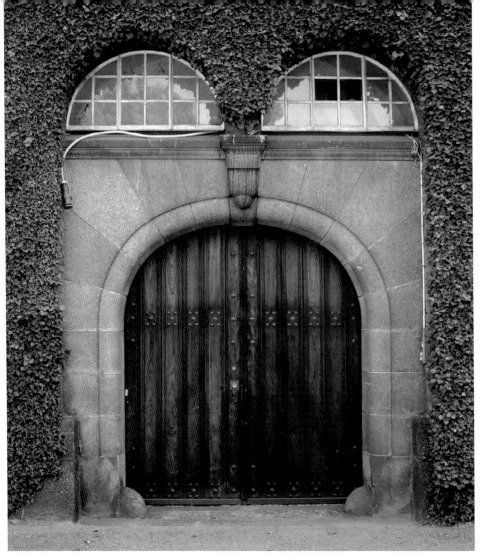

Green giant

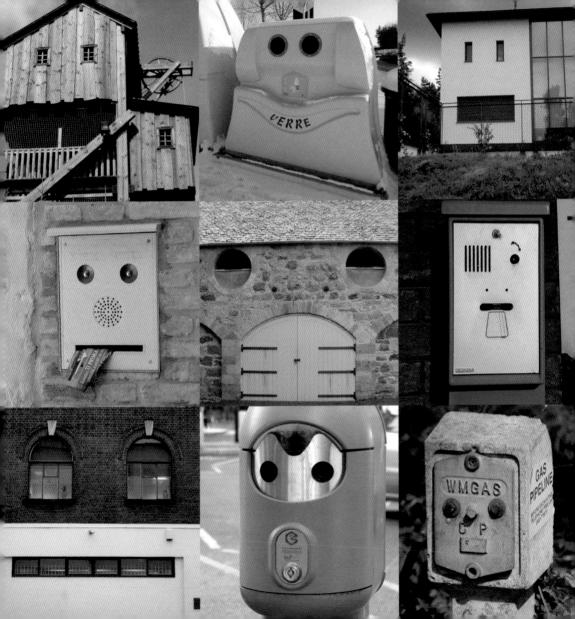

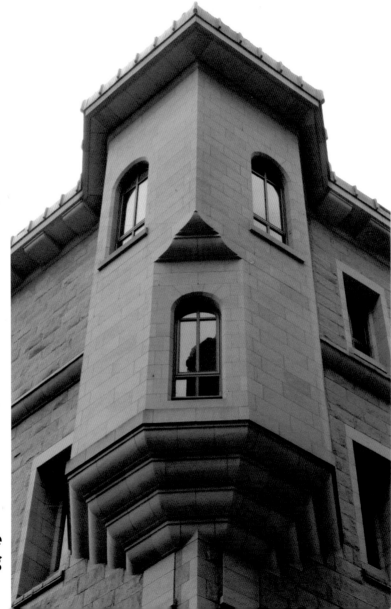

In fine song

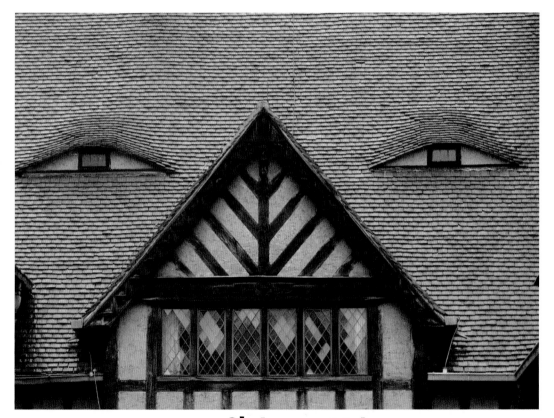

Sly house watches your every move

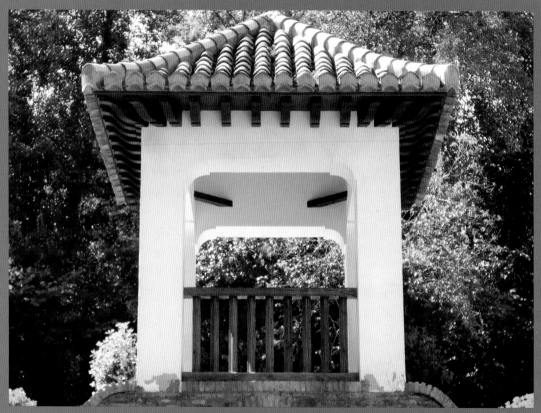

Beware...

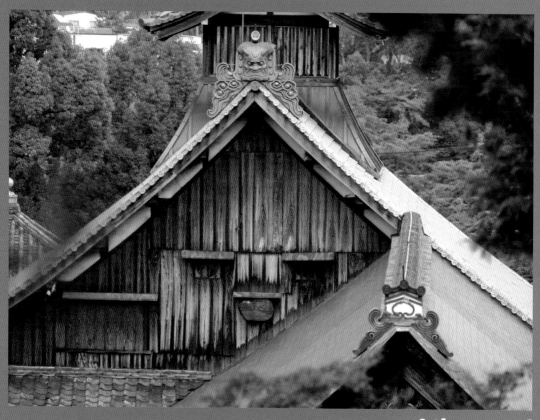

...of the samurai

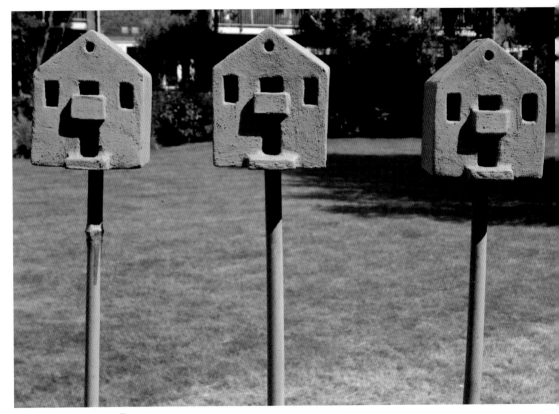

Terrace triplets

Car gobbler

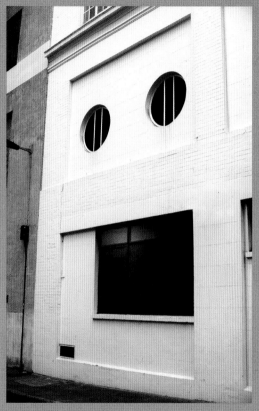

Shouting shop

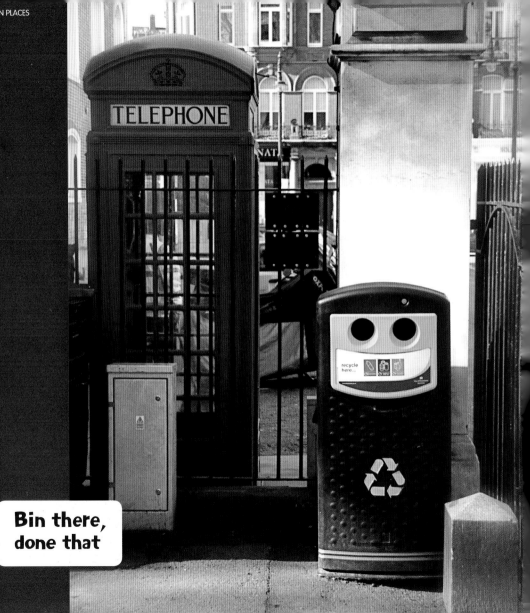

TELEPHONE

recycle here…

Bin there, done that

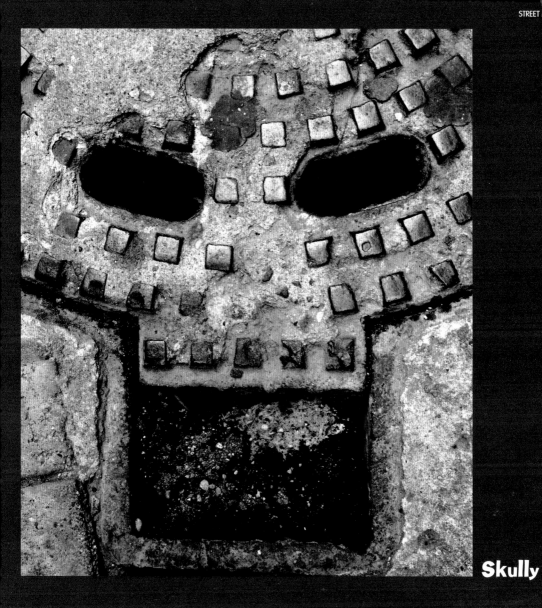

Skully

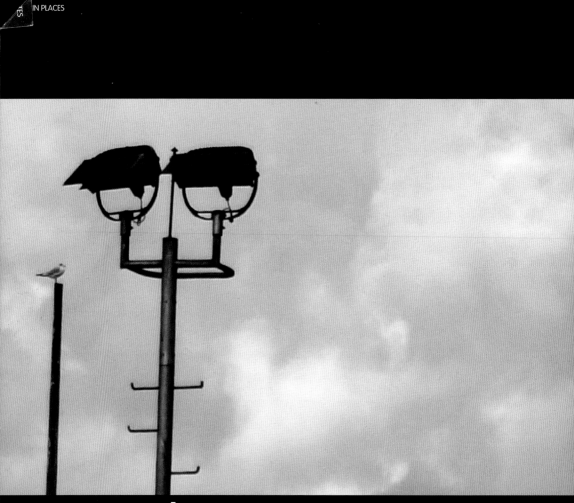

Superior streetlamp is unimpressed

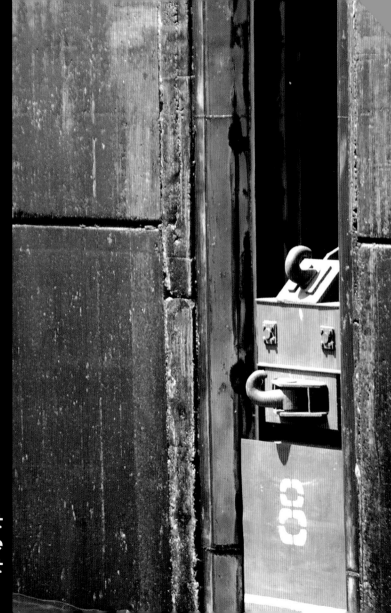

**Sneakybot
waits for the
right moment**

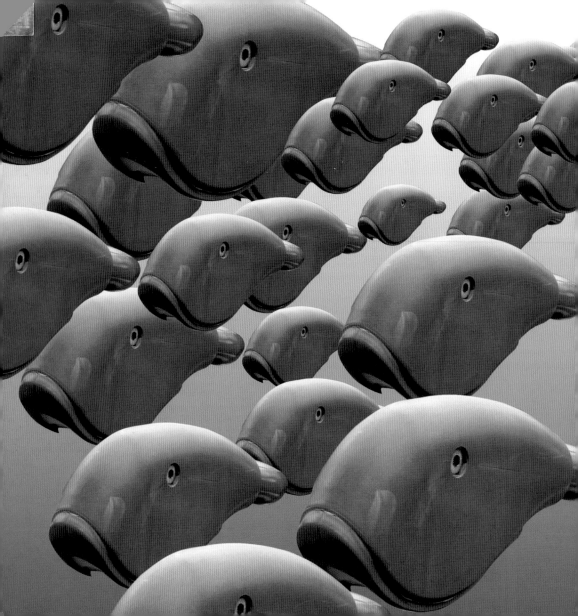

Chapter 5

Creature Features

Welcome to the secret zoo, a menagerie of objects with faces that resemble our friends in the animal kingdom, whether it's a snapping reptile, a curious rodent, a fish or a fowl.

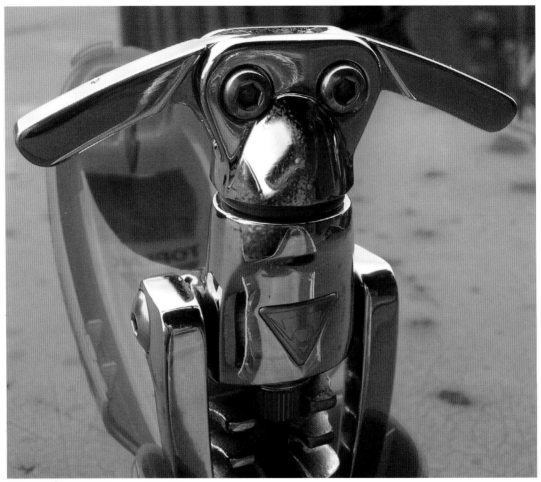

Walkies!

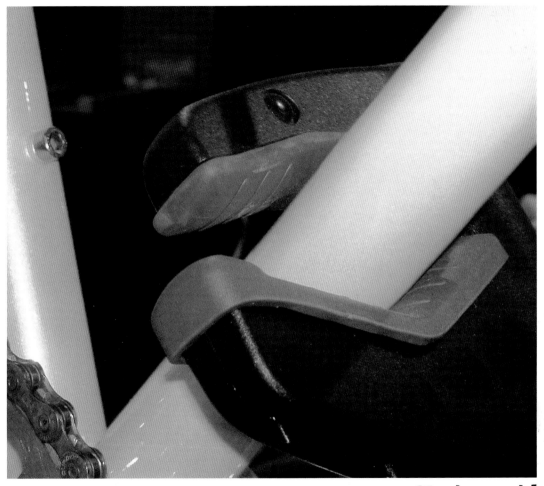

Shark attack!

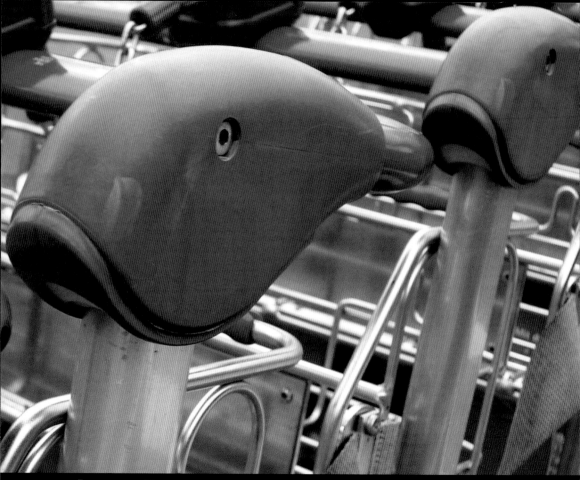

Shoal of trolleys

His bark's worse than his bite

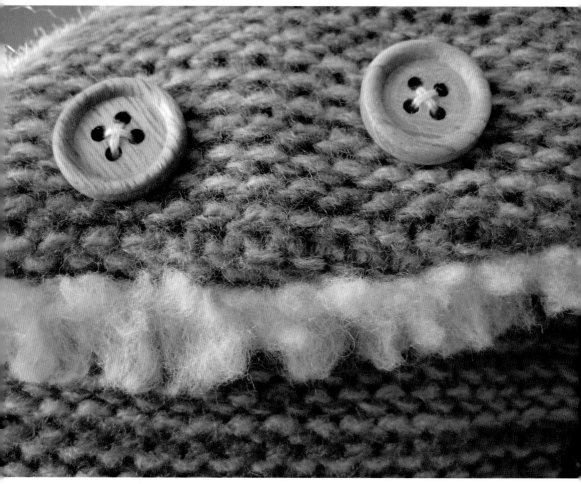

I am the walrus

Don't startle the lizard...

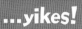

...yikes!

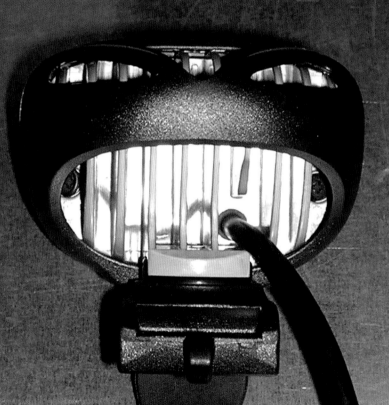

Angling for the angry fish

Cookie monster

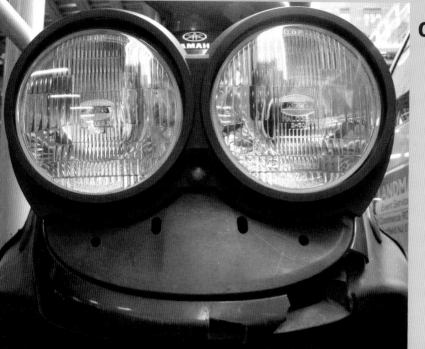

Robo crab

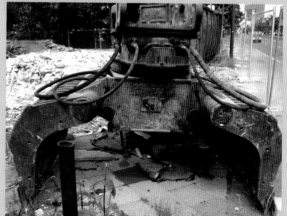

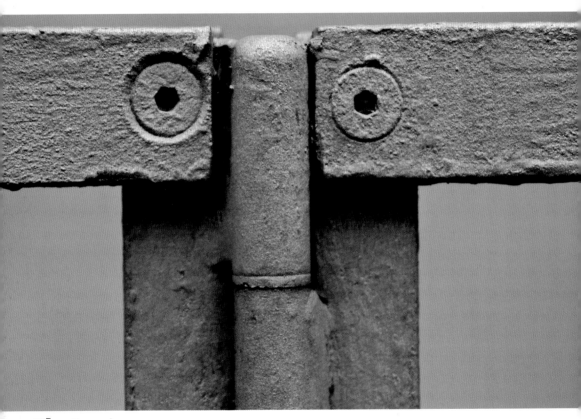

Elephant man

A purrrfect family...

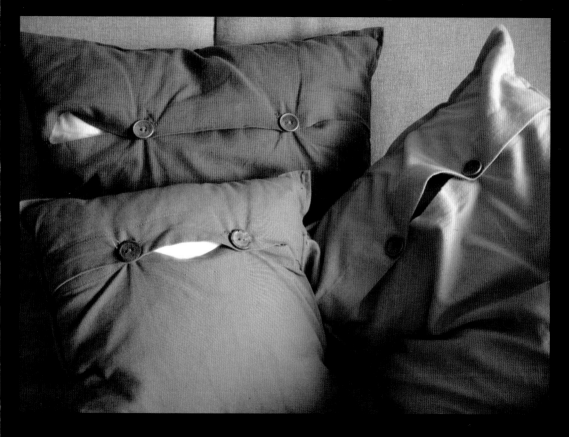

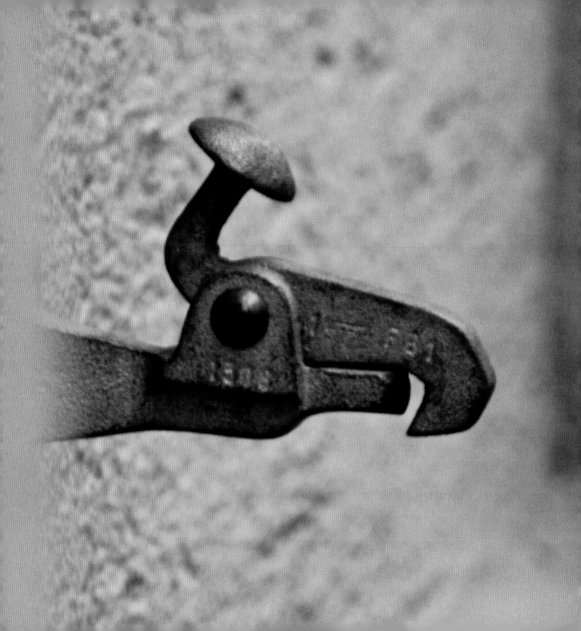

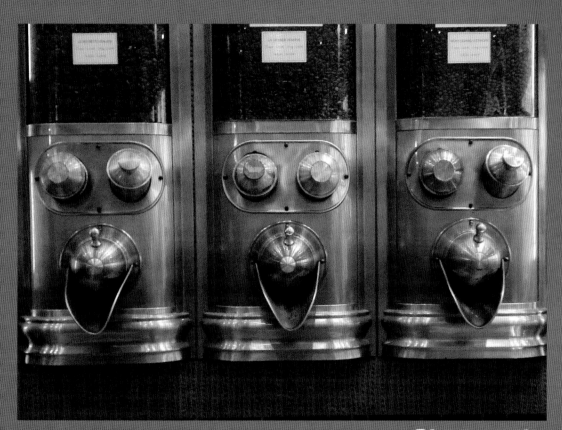

Birds on a wire

« **Dino-saw-us**

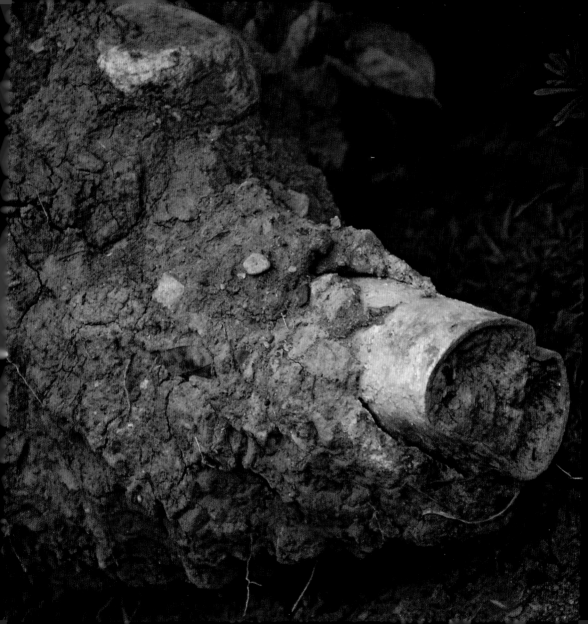

CREATURE FEATURES

« **Happy as a pig in mud**

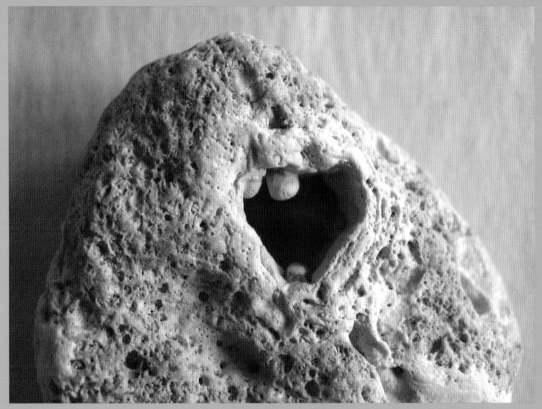

Sloth love chunk!

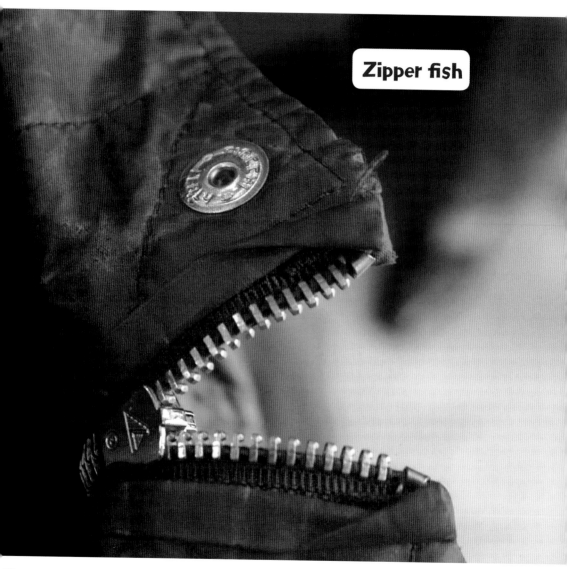

Zipper fish

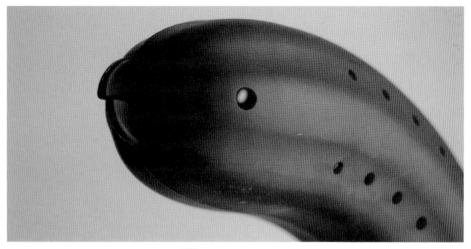

˅ Bunny block

˄ Tweety bird

˅ Ribbit!

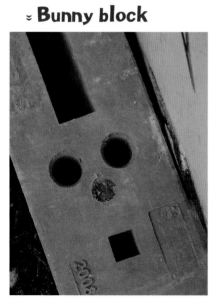

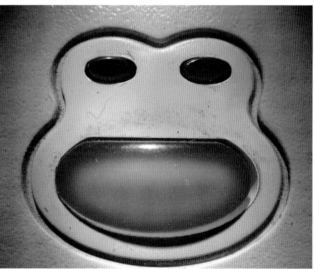

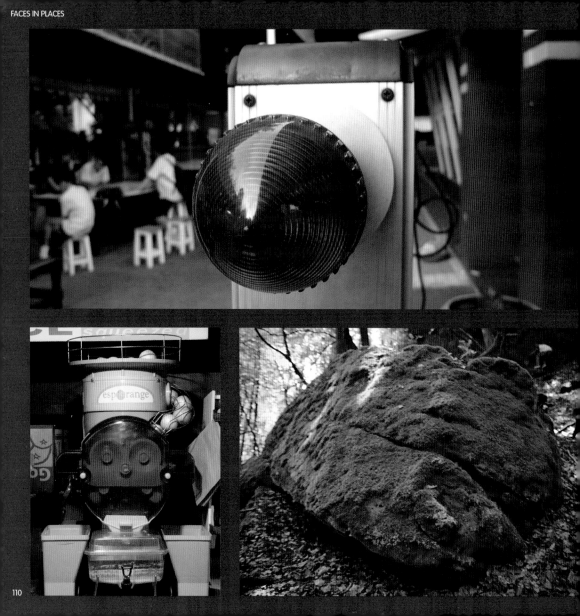

The crow

Guppy's barking mad

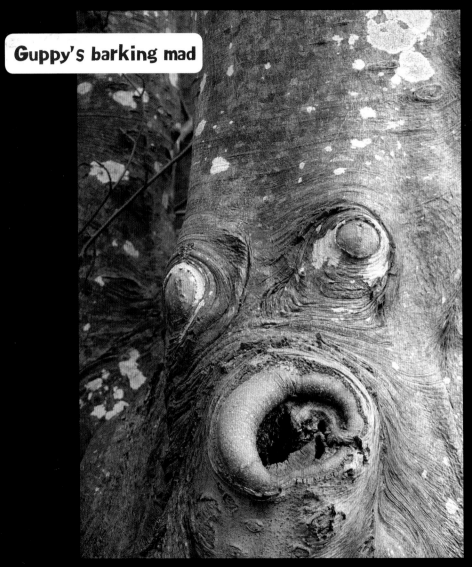

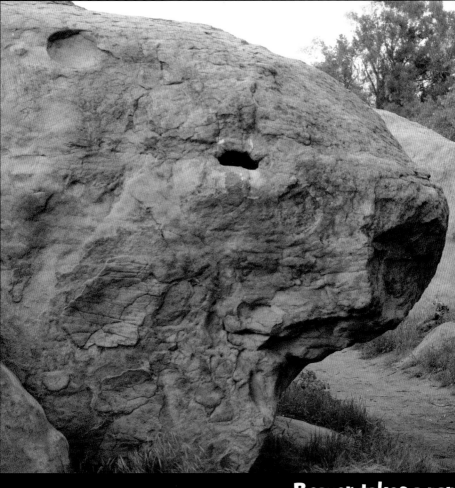

Beaver takes a nap

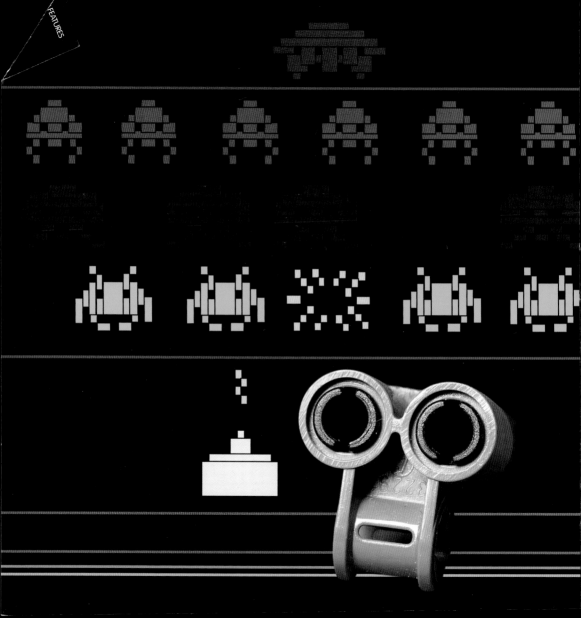

Chapter 6

Face Invaders

The invasion has already begun! Alien beings are infiltrating our everyday life, and if you're vigilant you'll be able to spot their faces in appliances, machines or concealed in nature.

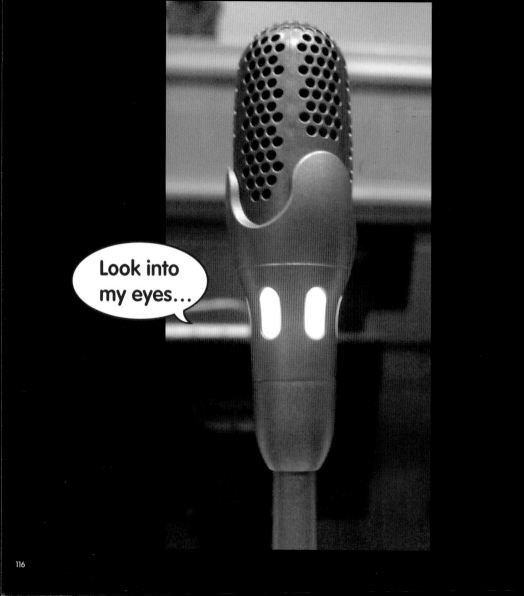

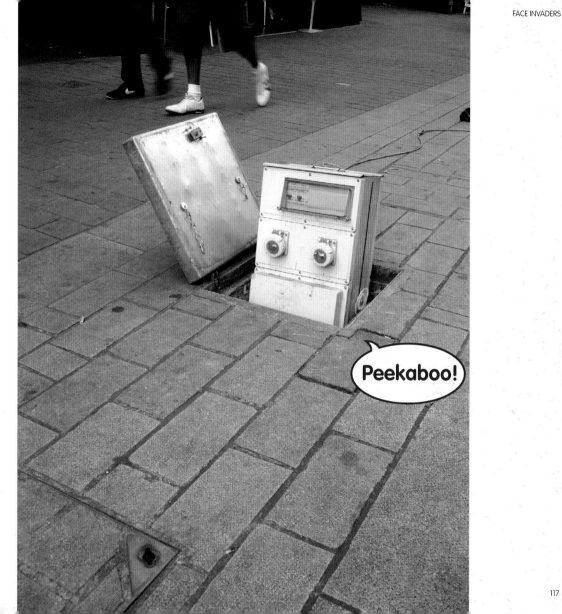

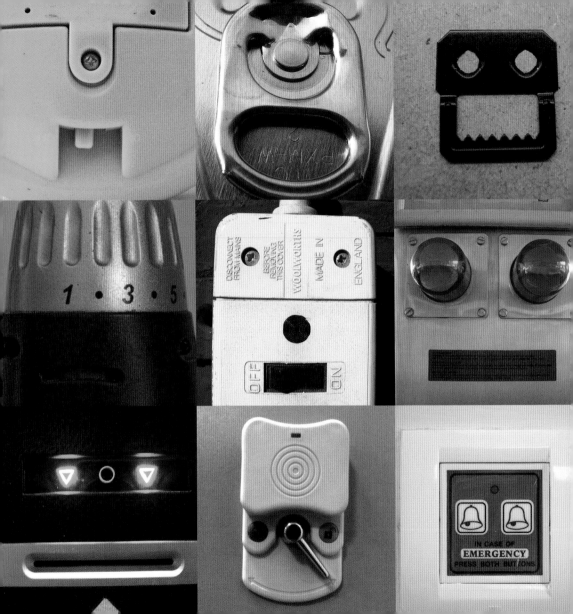

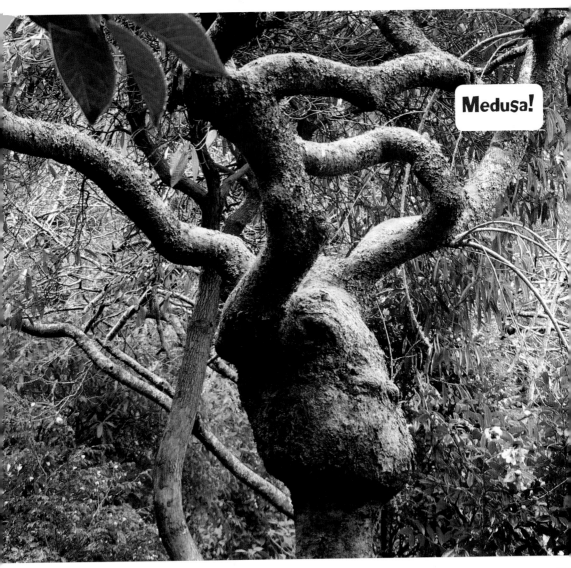

Medusa!

Gobby bot

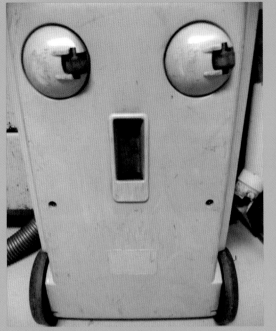

˅ Ghostly sucker

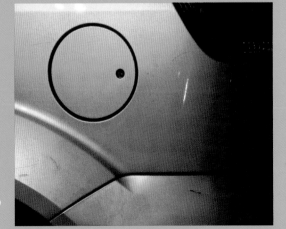

˅ Merging into the foliage

Fuelled up

Mad as hell

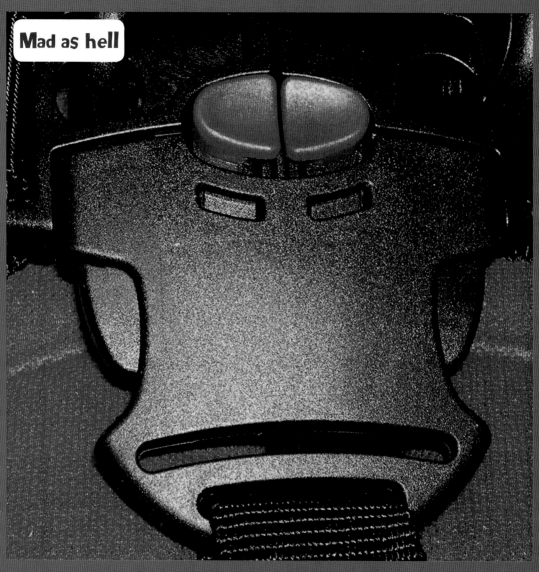

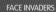

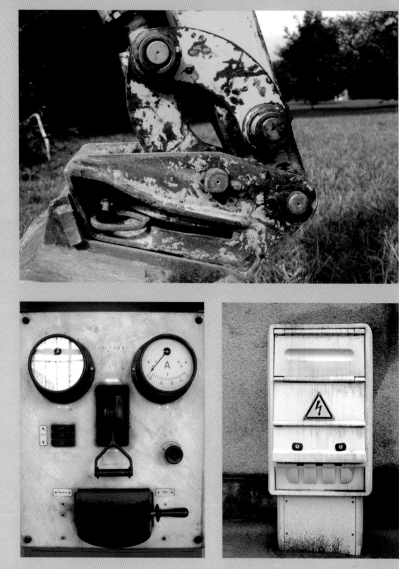

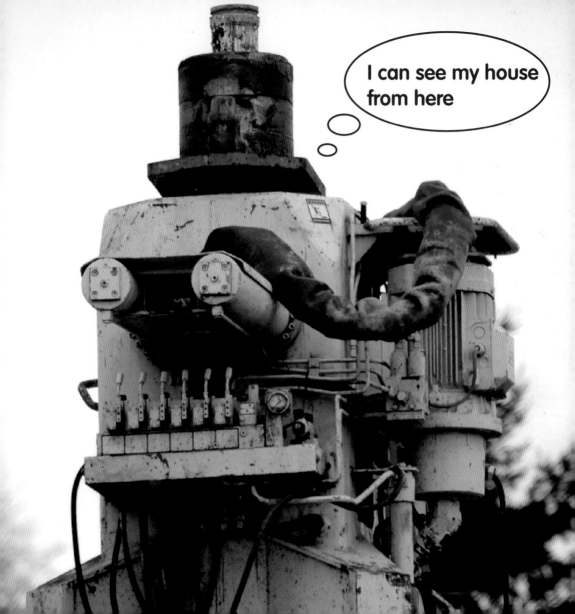

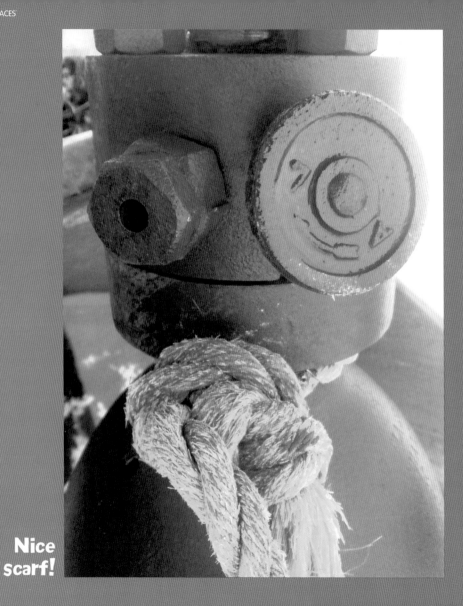

**Nice
scarf!**

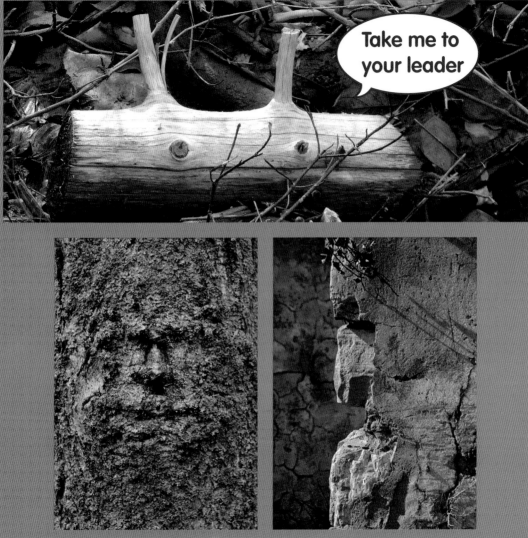

Stony stares

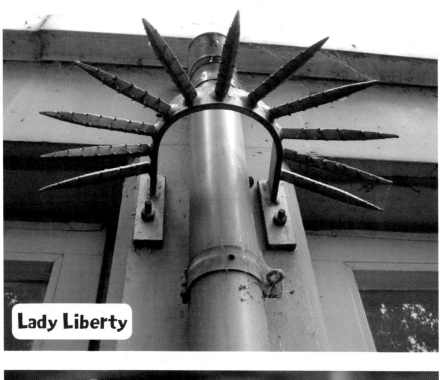

Lady Liberty

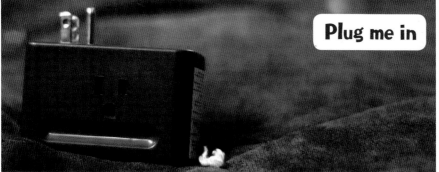

Plug me in

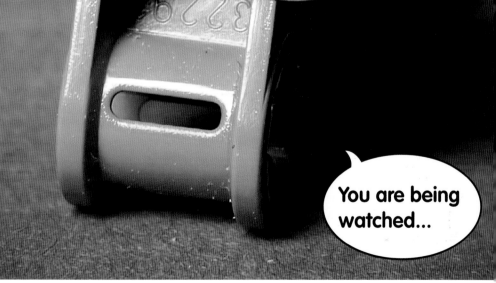

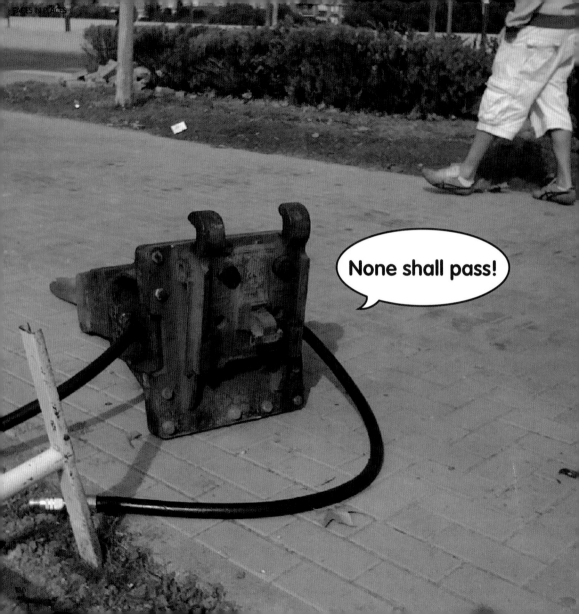

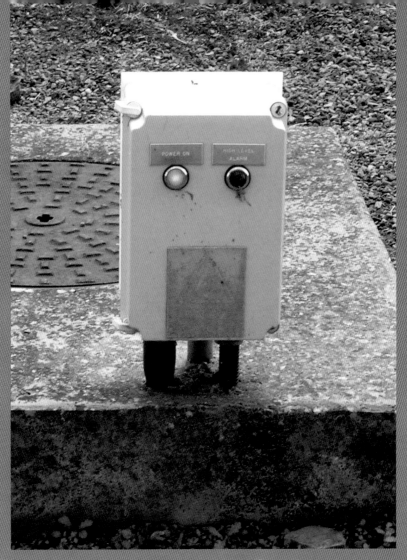

Bowie-eyed bot

Stealth bin disapproves of your litter

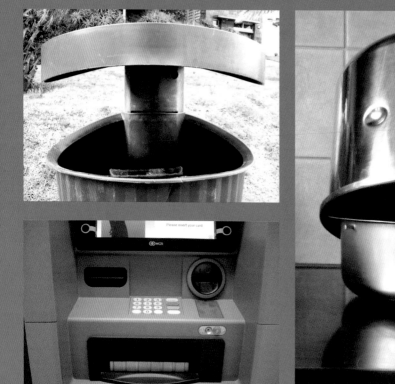

The cash man

Pan man

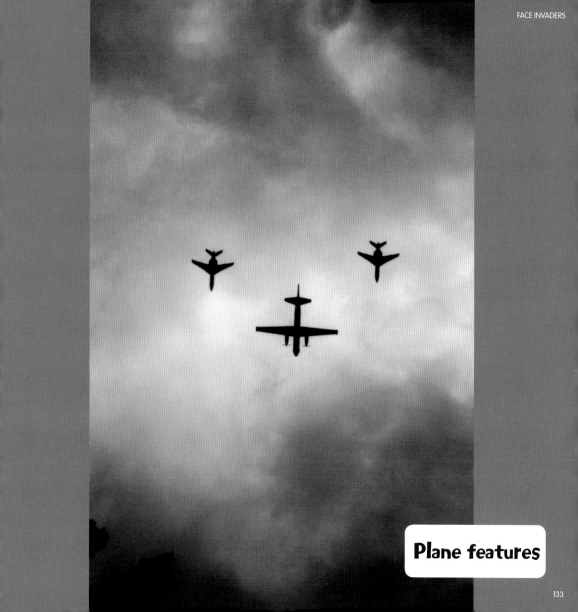

Plane features

Look out (for faces) wherever you are!

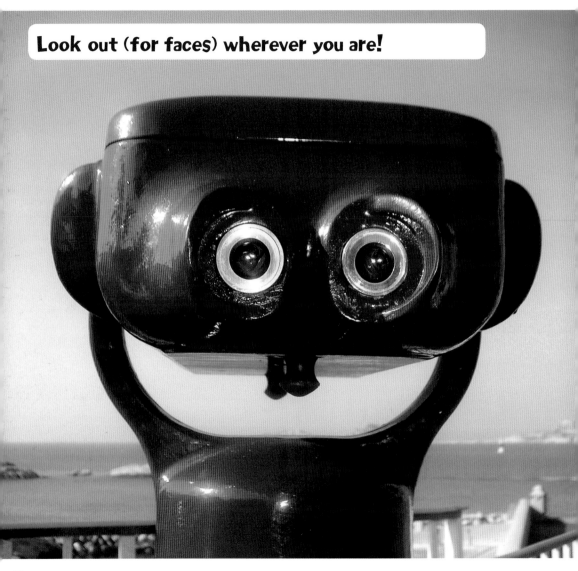

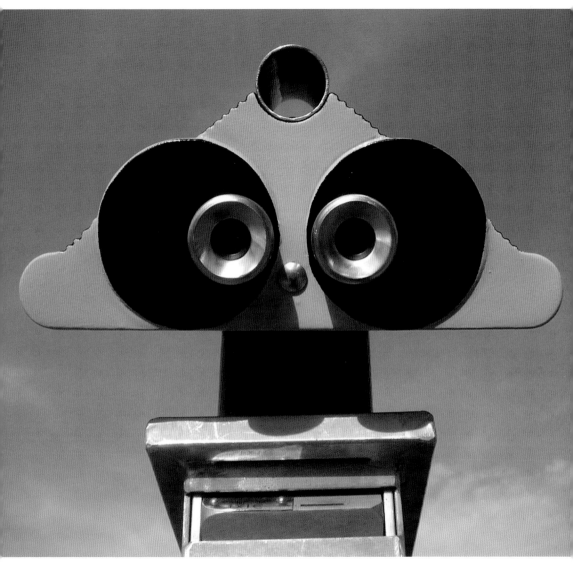

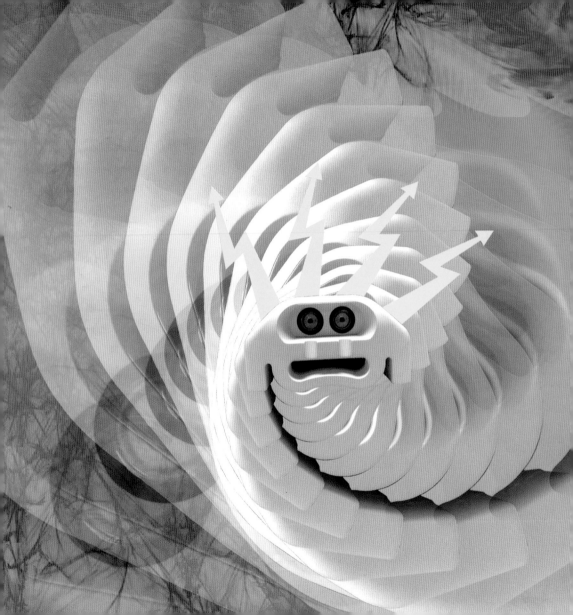

Chapter 7

Shock and Awe!

Surprise! Surprise! These characters really didn't see you coming, if their startled reactions – registering panic and amazement, disbelief and confusion – are anything to go by.

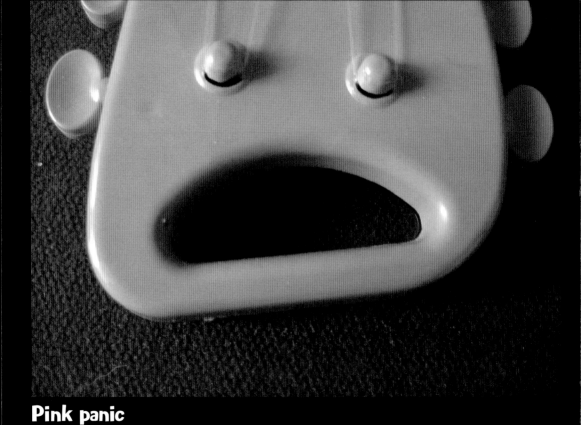

Pink panic

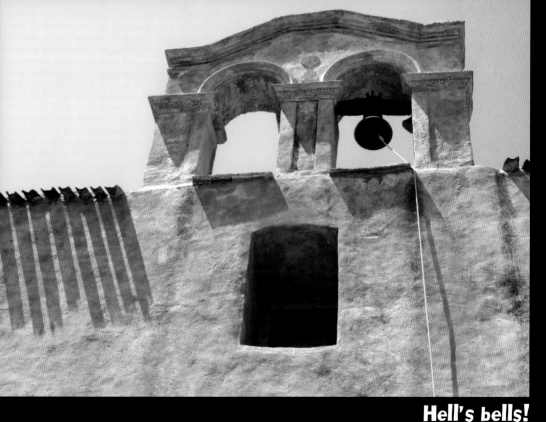

Hell's bells!

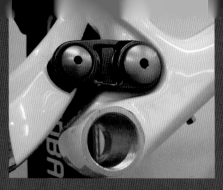

You did what?

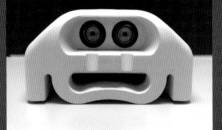

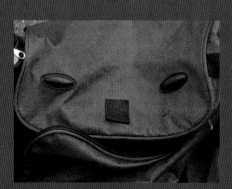

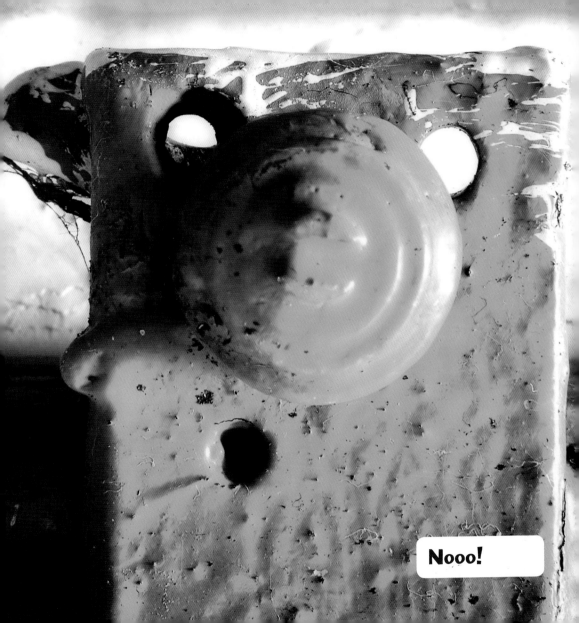

Nooo!

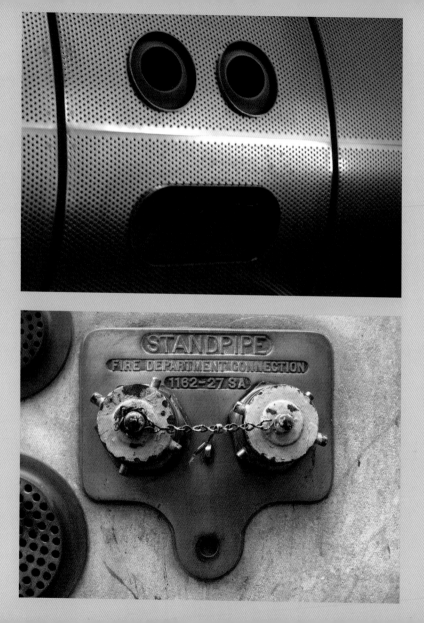

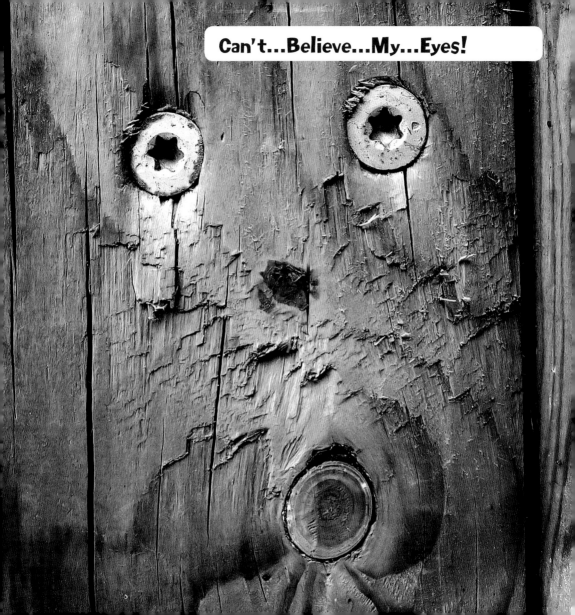

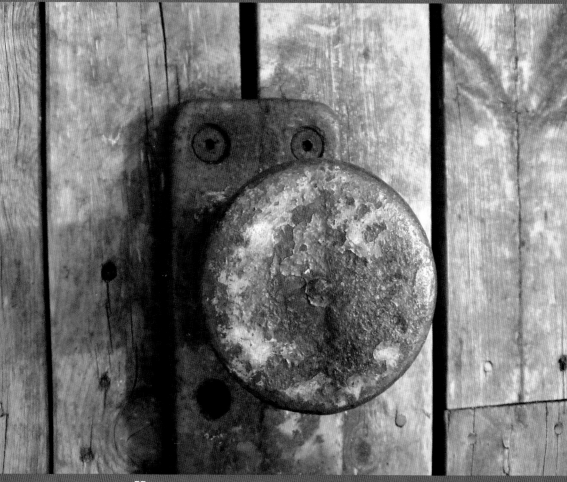

Who you calling big nose?

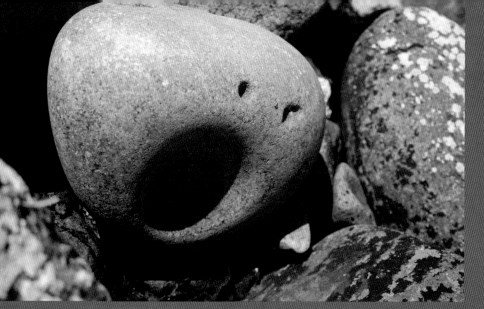

Shock rock

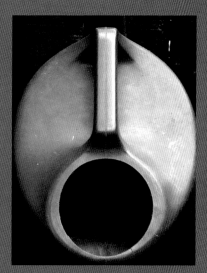

The Scream

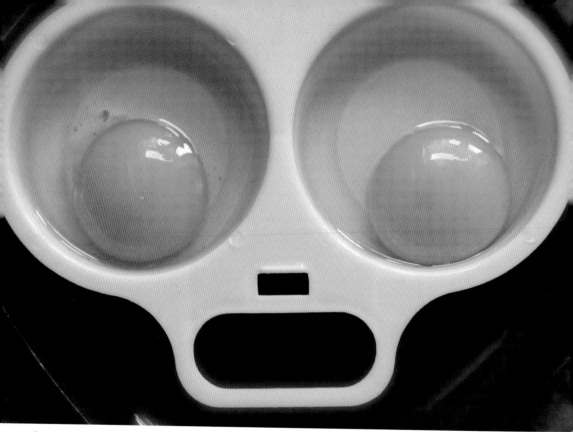

Scary movie

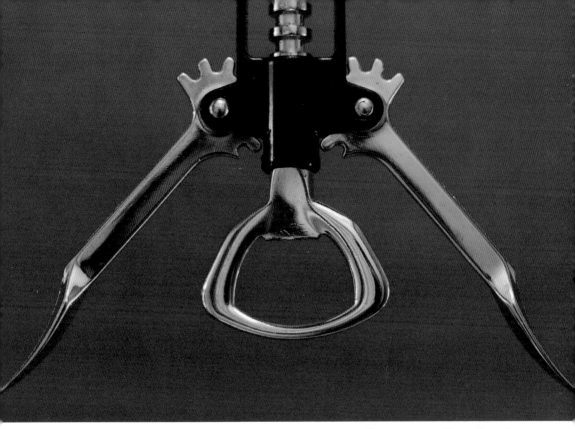

Screwed in the head

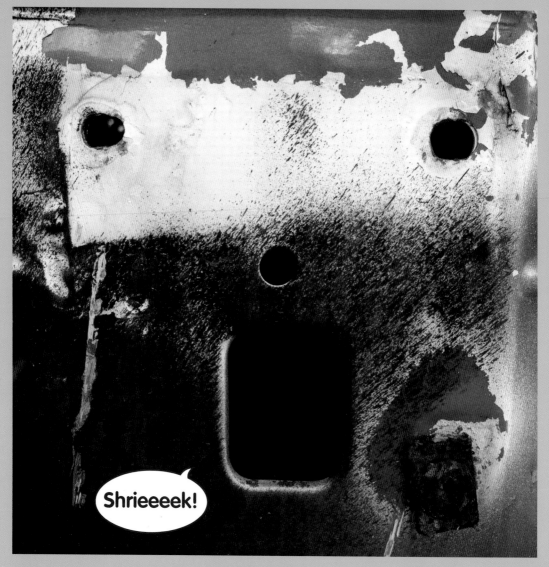

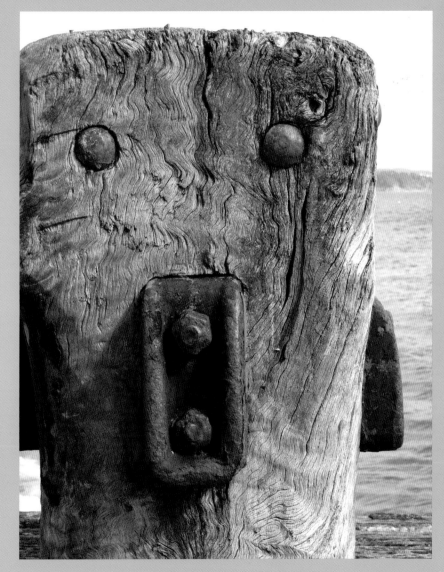

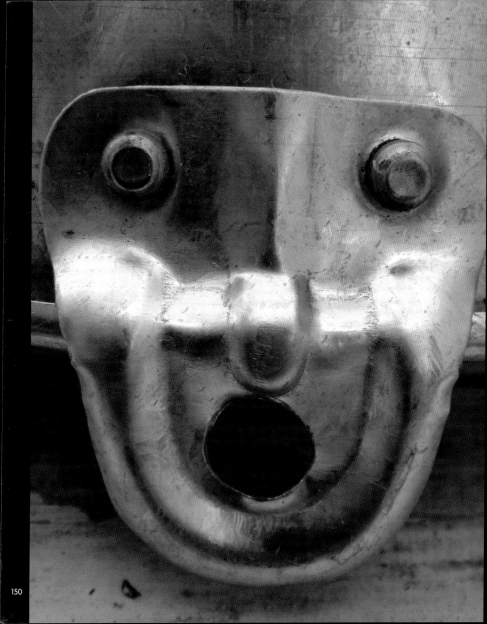

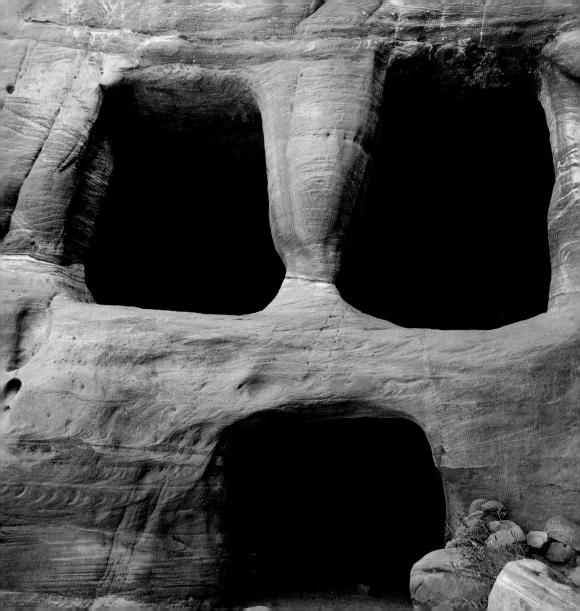

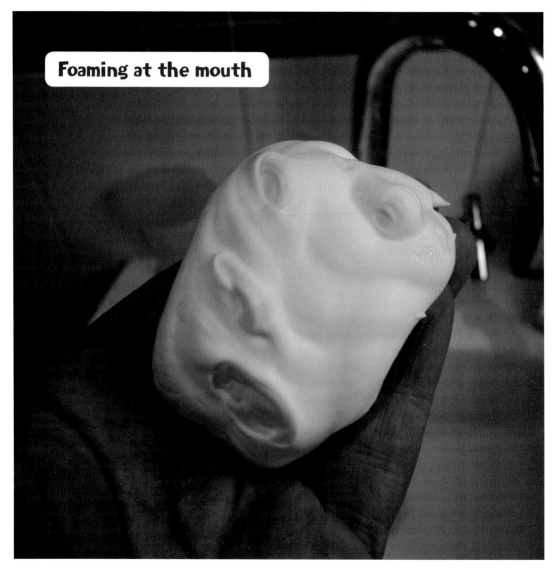

Foaming at the mouth

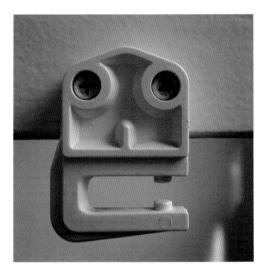

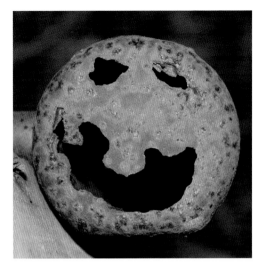

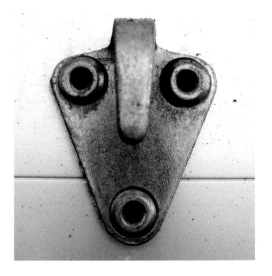

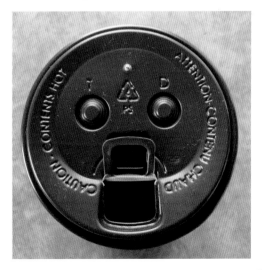

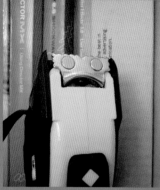

Getting the measure

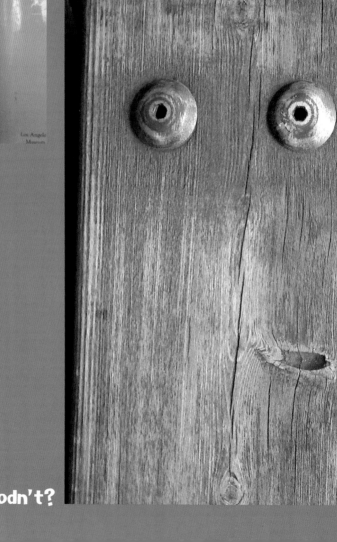

You woodn't?

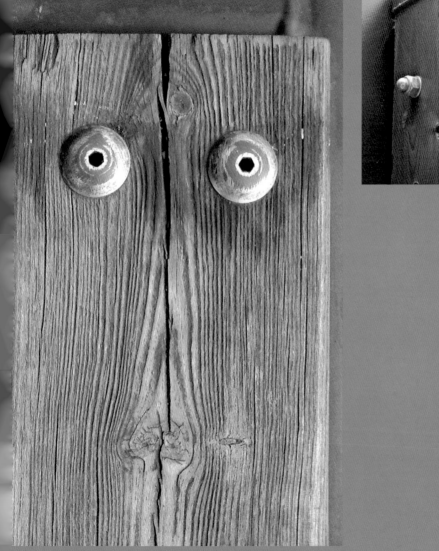

Confusion has a face

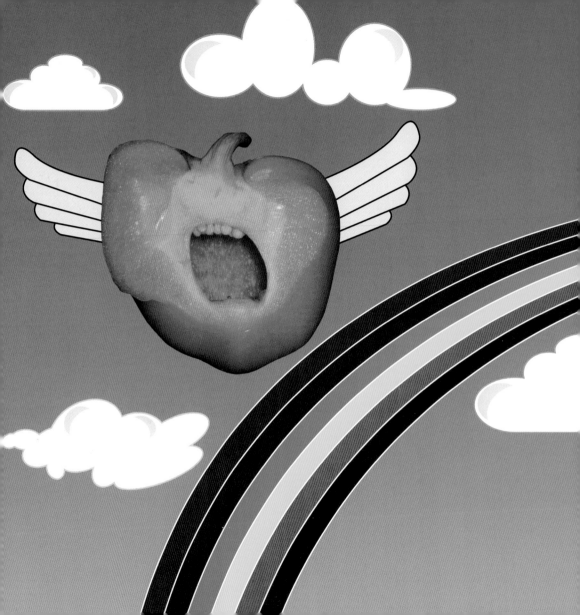

Chapter 8

You Are What You Eat

Think twice before sinking your teeth into your dinner. Chances are, your food may bite back! Here's a feast of faces found in fruit and veg, cakes and cookies, and other delightful dishes.

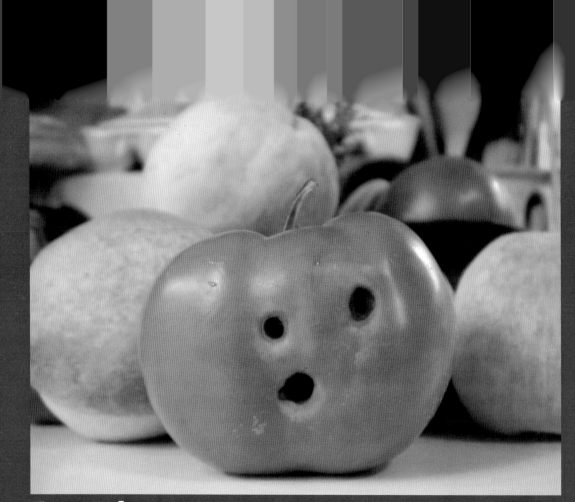

Tomat-oh!

Dr Pepper wants your brains for breakfast

**The
ice man
cometh**

**Do you
know the
muffin
man?**

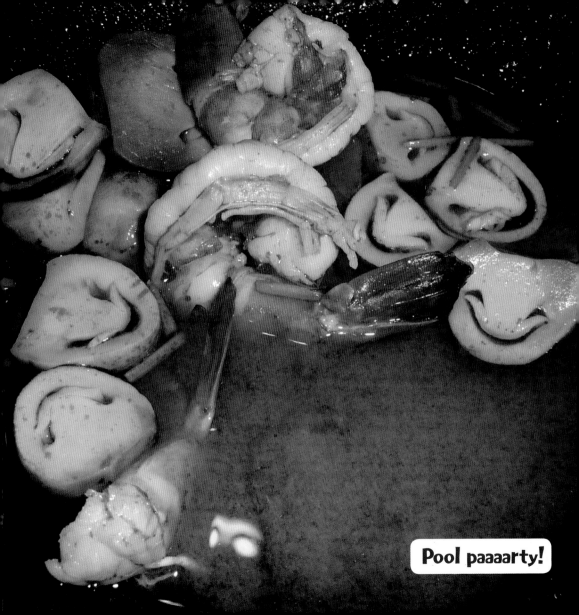

Pool paaaarty!

The curious orange

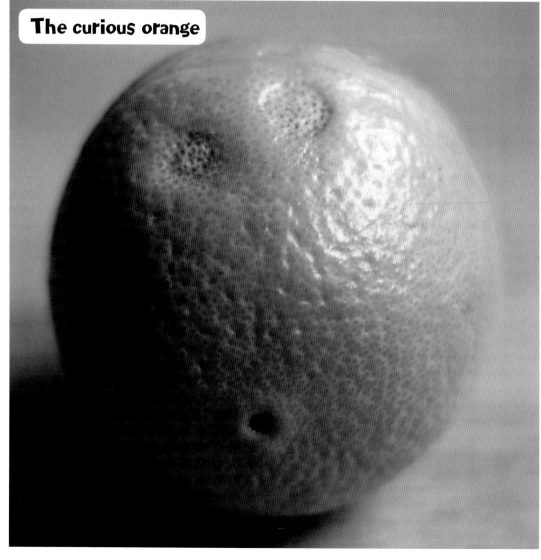

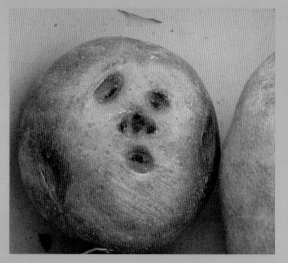

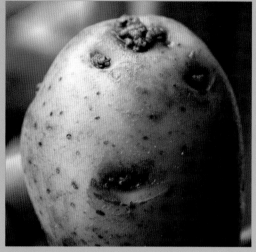

Spud brothers

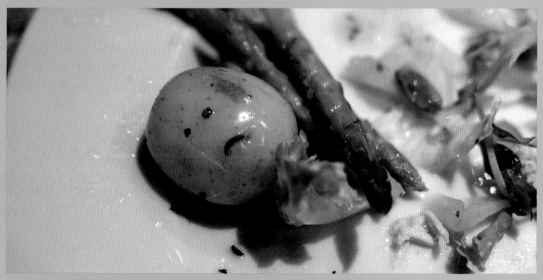

He's the icing on the cake

⌄ Crooked cookies

⌃ Sleepy dumpling

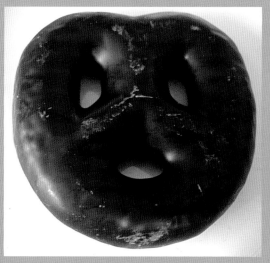

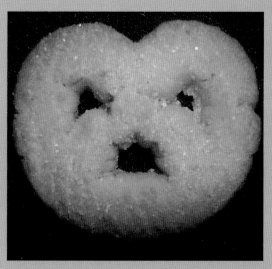

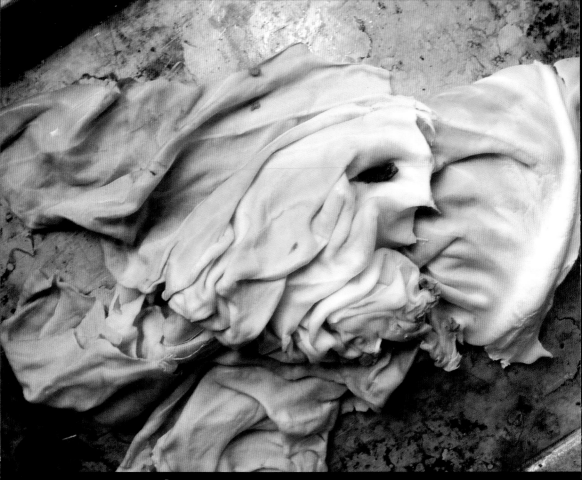

Cabbage patch kid

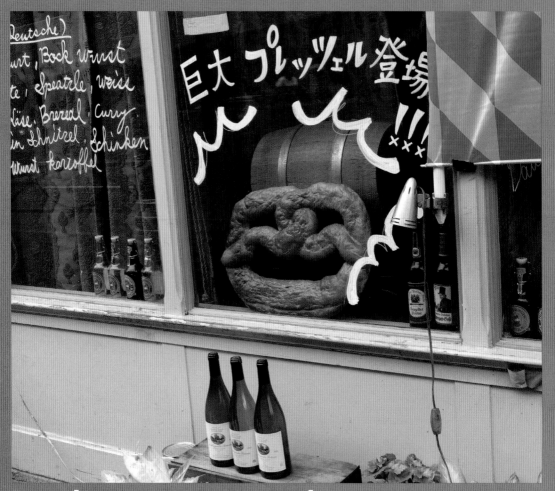

Pretzel approves of your wine selection

Chatty chestnut

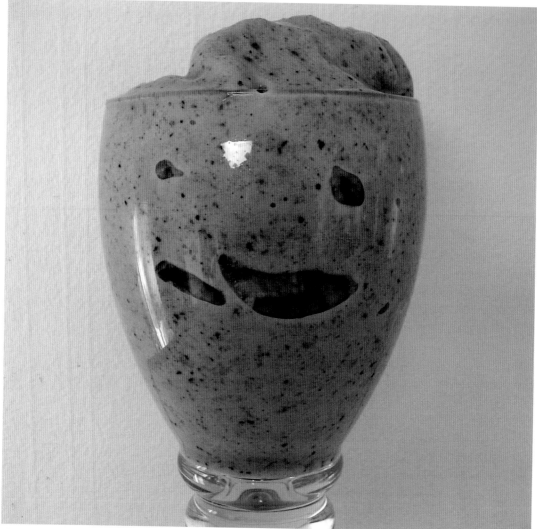

Smoothie operator

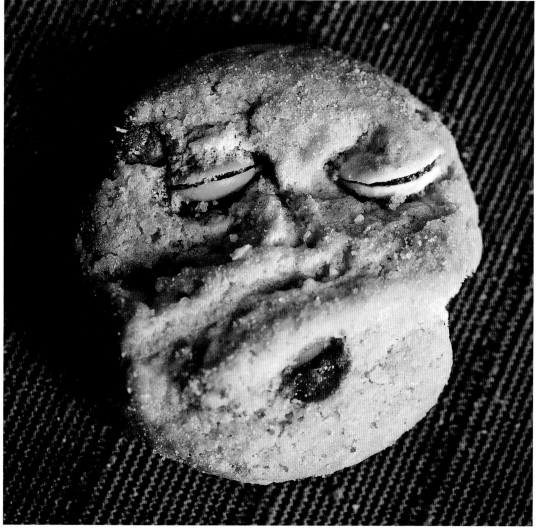

Sweet lips

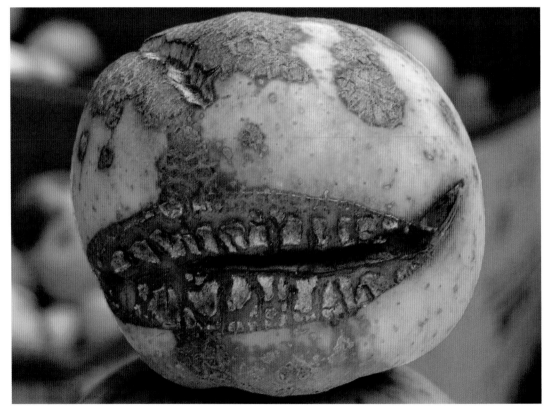

Crabby apple

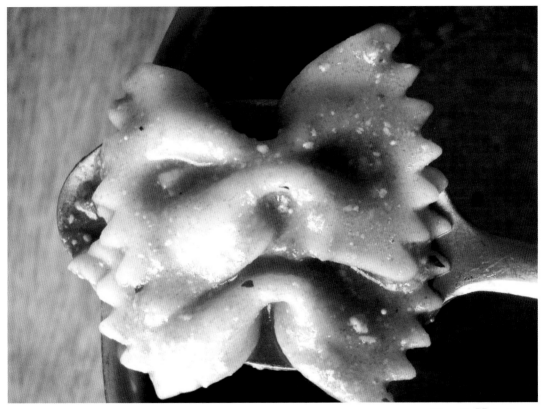

Farfalle fear

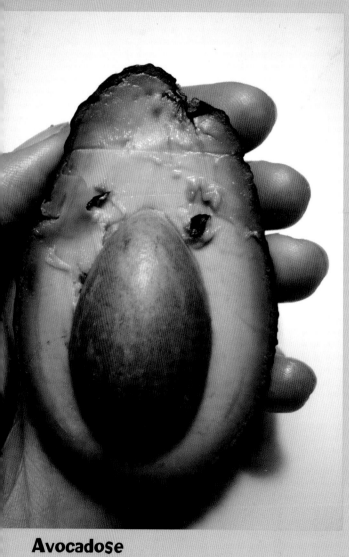

Avocadose

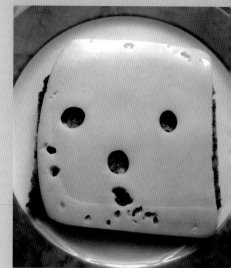

The Baby Cheeses

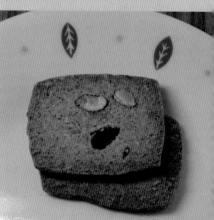

Nutty stare